Sketching People

FACES AND FIGURES

Giovanni Civardi

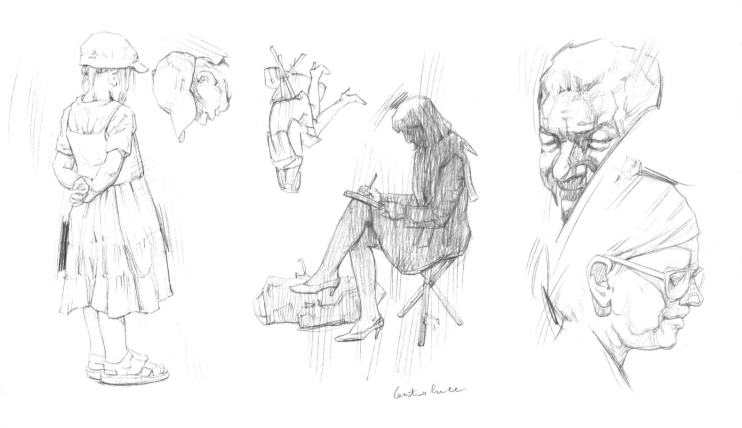

SEARCH PRESS

CONTENTS

Giovanni Civardi, November 2007

Giovanni Guglielmo Civardi was born in Milan in 1947. Following a period working as an illustrator and sculptor, he spent many years studying human anatomy for artists. He also teaches courses on drawing the human figure.

*'The perception of solid form
is entirely a matter of experience.'*
 John Ruskin

*'Dans l'esquisse, les mouvements des personages
 sont rendu plus vivants par la seule indication
de l'allure générale…'*
*(What makes the gestures of people depicted in sketches so
lifelike is that they are rendered with one simple suggestion
of their general demeanour…)*
 Auguste Rodin

'Changer de nourriture donne de l'appétit.'
(A change in diet sharpens the appetite.)
 Vincent Van Gogh

First published in Great Britain 2011 by Search Press Limited, Wellwood, North Farm Road, Tunbridge Wells, Kent TN2 3DR

Reprinted 2013

Originally published in Italy by Il Castello Collane Tecniche, Milano

Copyright © Il Castello S.r.l., via Milano 73/75, 20010 Cornaredo (MI), 2009 Schizzi di Volti e di Figure

Translation by Cicero Translations

Typeset by GreenGate Publishing Services, Tonbridge, Kent

ISBN: 978-1-84448-683-0

The figure drawings reproduced in this book are of consenting models or informed individuals: any resemblance to other people is by chance.

Printed in China

INTRODUCTION

Drawing the human form is one of the richest and most complete experiences an artist will encounter. But whether you wish to draw the entire body or just the face, the fullness of this experience is only achieved by hard work and application. The usual approach to learning about the figure is through life study: studying the anatomical form of a living model. Alongside this method – which has provided the foundation of artistic training for many centuries – there is also the possibility of branching out from our academic study of models to include models who have been volunteered, so to speak: people we find everywhere around us in the streets and in public places; people, in short, in all their different shapes and sizes, and with their multitude of body postures, gestures, moods and expressions. To be able to carry out this kind of supplementary study it is important to develop a constant habit – *nulla die sine linea* (not a day without a line), as the ancient maxim puts it – of making rapid drawings or sketches from life depicting people going about their daily lives.

What is a sketch? There are various interpretations as well as different purposes or ends, but the term is commonly used to refer to a fairly quick, spontaneous drawing of something from life that is represented swiftly and with a few essential strokes. In addition, a sketch can be a note, made in graphic form, of a sensory experience; it can constitute the starting point of a project; it can be a means of gathering visual information ahead of a large-scale work; it can be a preliminary study for a complex, composite work or, lastly, it can be made in order to study the form of a subject either viewed as a whole or when focusing in on particular details. For all these purposes, the sketchbook becomes a precious tool for artists as well as their richest source of information and recollection.

As a rule, a sketchbook is not intended for public display. It is both intimate and personal, which is why it allows the artist to experience things in a completely free, spontaneous and exploratory way. Knowledge of how to portray strangers who have been caught in all kinds of postures and circumstances is important for an artist's technical training and for the growth of his or her critical abilities. Indeed, perseverance in the practice of sketching will result in the refining of an artist's gifts of observation and interpretation and it will lead to an ability to see deeply; it will help in making choices that are rapid, confident, essential and concise. This is because the ability to draw people, with all their many subtle differences of face, figure and gesture, stance, movement and so on, derives, above all, from careful and thoughtful observation combined with an indispensible knowledge of anatomy and proportion and this is then transformed through the artist's personal interpretation.

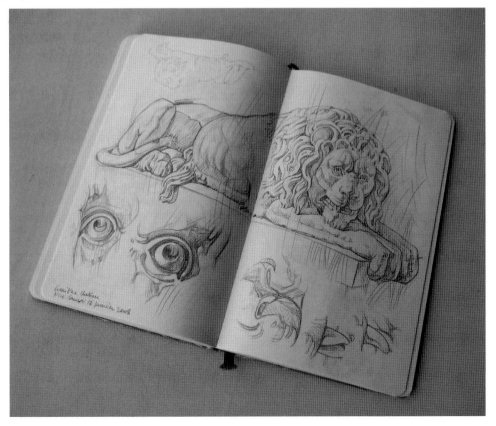

3

MATERIALS AND TOOLS

In essence, a sketch is a piece of 'visual note taking' and there is no reason why it should not be made on any sheet of paper or smooth surface, especially when dealing with a rapid and improvised summary of an interesting environmental or human situation. Many artists have made sketches on paper napkins, till receipts, on the pages of newspapers and books or scraps of packing paper – even on the walls of their studios or on the backs of painted canvasses.

However, it is clear that, apart from unexpected situations, a slightly more suitable material is preferred. This may be a bound notebook with blank pages, perhaps small in size (9 × 14cm / 3½ × 5½in) or medium-sized (13 × 21cm / 5 × 8¼in), or a typical album-sized artist's drawing pad. Sketchbooks and sketchpads may be made up and bound by the artists themselves, using the size and quality of paper that best suits their purpose. You can do this by simply folding and joining sheets of paper together and enclosing them in a hard cover (an indispensible support, given that we draw holding the sketchbook in one hand).

Commercially available sketchbooks have the advantage of being pocket size, making it easy to have them ready to hand at all times. The papers also come in various weights, colours and qualities: light-grade paper is suitable for pencil sketches, a slightly heavier paper will take pen strokes and coloured crayons, while wet techniques (watercolour, wash, etc.) require paper that is heavier still, although excessive applications of water will cause even these surfaces to pucker.

It is a good idea to insert a sheet of flimsy paper between facing pages that have been drawn on in order to avoid smudging or staining, especially if they were drawn using soft graphite. The same care should also be taken while sketching in order to prevent the hand that is resting on the paper from moving material around.

A sketch is made quickly and should always be fluent, free and concise – characteristics that clearly differ from those of a more elaborate or fully finished drawing. Suitable tools, therefore, are the simplest ones that can be picked up and used immediately, as long as they suit the artist's style and technical preferences.

The pencil Ordinary pencils may be used: those with the lead enclosed in a wooden sheath, or mechanical pencils with graphite leads that are inserted into a button-operated sleeve (mechanical pencils). These have very fine leads with diameters between 0.5mm and 0.7mm. These are rather fragile but have the advantage of not needing to be sharpened. Different shades of graphite are represented on a conventional scale ranging from the hardest (9H) to the softest (9B) with the middle of the range being represented by HB or B. Soft graphite leads deliver a full, pliable mark on the paper which is ideal for impulsive drawings 'in one go', but which are not too confined in scale on a sheet of paper not smaller than, say, 20 × 30cm (8 × 12in). Medium and hard leads are suited to making sharper and more detailed sketches (which are nonetheless fast and concise), even working on a very small scale.

Woodless graphite sticks and crayons These are small sticks made entirely of graphite with a diameter roughly between 5 and 15mm (¼ and ⅝in), which can be held directly or using a purpose-made metal handle. They are usually manufactured out of graphite paste ranging from soft to very soft (from B to 9B), which is why they really only come into their own when used on rather large surfaces. They also allow you to indicate large areas of shade with a few forceful and concise strokes.

Charcoal This is a very delicate and soft tool, especially when made out of carbonised twigs. It can produce drawings with strong, clear-cut lines, or drawings that are extremely vague in their rendering of shade. However, due partly to the fact that charcoal is a very brittle material, it is poorly suited to drawing small-scale sketches in a sketchpad or sketchbook. More suitable for this purpose, though, is the kind of charcoal made of compressed lamp black, as this leaves a very dense mark on the paper and its properties of line drawing are similar to those of soft graphite sticks.

Coloured pencils These have characteristics similar to those of lead pencils, being easy to handle and leaving clear, soft lines. As they come in a wide range of shades for each colour, they offer a quick and easy means of noting details of colour in complex subjects, for example in a portrait or when depicting figures dressed in garments with striking colours.

Pen and ink These tools are also widely used and are very suitable for making quick and concise sketches. However, they are more demanding than a pencil because they leave an indelible mark on the paper. This is why they require the artist to be daring, as well as have a great deal of sureness of hand so that the end product is not muddled, blotchy or overly tentative. The opportunity for tracing faint guidelines in pencil, which can then be erased later on, is not really feasible for sketches of the human figure, which by definition have to be (and so appear) spontaneous and fluent, as well as being free of jarring 'second thoughts'. The classic tool set for drawing in pen and ink comprises a penholder, nib and bottle of coloured or black India ink. While unrivalled in its versatility, this does not adapt very well to impromptu sketches, especially of figures and faces spotted in outdoor situations. There are at least two reasons for this: first, the charge of ink in the nib is used up in a few strokes and this slows down the speed of the sketch, and secondly, the metallic nib can get caught in the fibres of sketchpad paper (which is often fairly light and low grade in quality) producing unwelcome spots or tearing. The bamboo pen presents similar problems, although it is a little more amenable to this kind of work. Pens, on the other hand, such as ballpoints, fountain pens, felt-tipped and technical drawing pens, are much more suitable in this case.

Drybrush technique A good alternative to a pen is a small paintbrush with natural hair or synthetic bristles. Once the brush has been dipped in the ink and suitably dried on a rag or piece of tissue, it is possible to draw on the paper with a very soft and flowing stroke, the width of which can be greatly varied, and also to fill in areas with blocks of shade that can be either opaque and solid or thin and grainy. In order to exploit drybrush technique to its full potential, the paper of the sketchpad should be of sufficient weight and slightly textured, and the size of the brush used should be correlated to that of the sketch you intend to execute. As soon as work is completed, the brush should be washed carefully in water.

Watercolours and lavis (ink wash) These media are seldom used for impromptu sketching of the human figure because they do not lend themselves very well to this kind of spontaneous, unforeseeable 'note taking'. Indeed, even the minimum amount of equipment required becomes cumbersome with both the artist and subject assuming fleeting poses in a public place. At most, large areas can be blocked in, either in colour, using watercolours, or by the monochrome lavis technique of diluting black ink (or any other colour) with water. Such touches of colour and shade can also be added and worked on afterwards, with the pencil sketch already finished and both the time and the means available for supplementing and enriching it. It is, however, advisable to be aware that such a procedure can easily 'weigh down' the sketch and remove its freshness.

Other tools In order to gain experience in using them and to experiment with new or unconventional effects, you might like to try out other media – although they might not be among the most convenient for executing the kind of sketches we have in mind here. For example, oil or acrylic paint (which can also be used for drawing with), either on coloured paper or canvas panel, or using metal tools on a surface coated with china clay to produce a drawing in ink (scratch-board), etc. It has now also become possible to sketch using an electronic pen on a portable laptop.

Accessories This is, of course, a basic overview. Pencil and paper are all you really need to make an impromptu sketch of human figures in an outdoor scene. Nonetheless, it could be useful to have at least a plastic eraser to hand – not so much for erasing mistakes as for removing excess marks or spots of graphite from the paper – and a bulldog clip to hold the pages of the sketchbook while you are working.

Note All of the drawings reproduced in this book have been taken from numerous sketchbooks that I have kept at different times and in various places over the past three or four years. Some of these sketchbooks are small (9 × 14cm / 3½ × 5½in) and others are larger (11 × 21cm / 4¼ × 8¼in). I only used a fine HB lead (0.5mm), which gives a medium-soft tone that I find very versatile.

It soon became evident that the printing of these drawings would present considerable difficulties as they were drawn in very different ways: the quality of line fluctuates between being so fine and faint that the lines almost disappear, and much thicker, darker strokes. This is the reason behind the relative lack of tonal unity, which it was my desire to leave deliberately uncorrected because as well as giving a true impression of the sketches, it conveys the sense of the freedom and variety inherent in the act of sketching and shows some of its constraints.

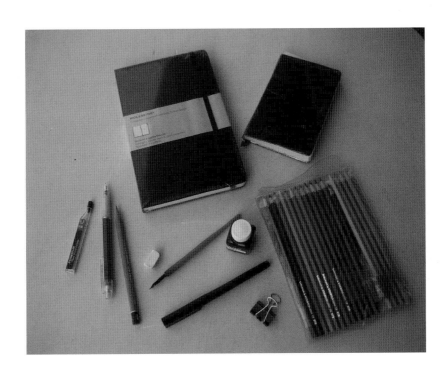

GETTING STARTED

It is more than likely that you make a sketch to get down the initial germ of an idea for a figurative work. However you go about it, your sketch will result from the careful observation of an object or situation, rendered by means of a few essential and meaningful strokes.

- Get into the habit of always carrying a pencil and small sketchbook with you – the kind that will easily slip into a bag or pocket so that it is always on hand when something attracts your attention or stimulates your interest. There can be many reasons for stopping to make a sketch, apart from the simple desire to keep your hand and eye in constant practice. You may wish to gather and note down important information, or analyse a complex structure or, in particular, keep your eye well trained in perceiving proportions, relationships and forms correctly. Then there is the motive of acquiring the ability to observe and select essential features, coordinating your observation, your judgement and the movements of your hand in graphic form.

- Do not worry about the aesthetic result of the sketch. It is no more than a simple piece of note taking, a private and personal visual record that is unlikely to be put on show for others to see. You should be more concerned with preserving the freshness and immediacy of the impression on the paper – never go back to a sketch to add finishing touches.

- Do not attempt to get everything down on paper that you see in a figure. Given the limited amount of time at your disposal and the temporary nature of the pose, you should concentrate on what is essential, or what you consider to be so. Therefore, once you have fixed the general lines of a figure's overall stance, or the attitude of a face, you should either do the same again (circumstances permitting), by analysing the subject from a different angle, or investigate the structure of individual aspects in greater detail.

An in-depth study of the human face and of the human figure can only be made using models holding poses for a sufficient amount of time in the studio. The impromptu sketch from life is nonetheless invaluable because it forces the artist to concentrate their attention on those few elements that are truly useful for describing a posture or an anatomical form. Like necessity, lack of time can be the mother of invention.

Sketching people in real environments, when the subjects are not posing for you intentionally and may be completely unaware that they are being observed and portrayed, might appear very difficult and even 'paralysing'. But there is no real reason for faint-heartedness or feeling daunted at the prospect of working in public – hardly anyone will notice what you are doing anyway. Diligence will certainly bring you many rewards, building up your confidence and improving your artistic abilities. Finding emotional and technical solutions to the obstacles that prevent you from carrying out a fully finished drawing will hone your abilities to explore and summarise, making your style of expression more personal.

There are almost unlimited opportunities for sketching faces and figures from life, whether outdoors or inside your home, and they offer the widest possible choice of forms, characters and poses. People are found just about everywhere but, in order to exploit these opportunities fully, it is desirable to find a comfortable vantage point from which you can easily observe the people around you without being disturbed. Ideal places could be, for example, restaurants, parks, beaches, public transport systems or museums. These are places where people slow down their pace of life or relax a little. Models and poses keep on changing, but there is still enough time to portray them after a quick and profitable few seconds of observation. If the person you are drawing changes their position, do not worry; you can start another sketch from scratch in the expectation that they will – probably – reassume their original pose, or a similar one, after a while.

If you feel too intimidated by the idea of sketching people from life (bearing in mind that, if they realise what you are doing, some may be pleased but others may get annoyed and react by walking off), you may be able to prepare yourself psychologically and improve your confidence by drawing statues and sculptures in museums or monuments in public places (see chapter 5). Apart from being a pleasant thing to do, this activity offers several great advantages: obviously, the model stays still and is there for all the time you require; depending on the kind of lighting, there may be a varying play of light and shade; you can analyse the subject from different and unusual points of view and study its details unhurriedly, etc. This is therefore a trouble-free method of gradually acquiring or deepening that indispensible knowledge of anatomy, the proportions of the head and body, perspective and foreshortening, and the effects of shade[1]. In fact, in order to make a good drawing of the human figure or face, the artist has to bear all of these technical aspects in mind simultaneously and apply them all in the short time allowed for executing the sketch. Nevertheless, once you have acquired experience through drawing in museums, try to move straight on to sketching figures from life.

Portraying a figure in movement is a truly difficult task. It is, however, one that should not be overlooked as it instils the habit of capturing the flow of the limbs, the direction of movement and the bodily attitudes that initiate and aid them. A great deal of attention is required for observing people and learning how to use your memory to reconstruct the basic sequences of movements. Try to anticipate the next phase of a given movement – many human actions (walking, running and dancing, for example) consist of repeated cycles and this makes it possible to reassemble their dynamic sequence from memory, concentrating your attention every now and then on an individual phase. In this respect, photography

1 You can find more on these topics in my other books, including *The Complete Guide to Drawing, The Nude, Drawing Portraits: Faces and Figures* and especially in *The Human Form*.

may sometimes prove useful, even indispensible at times, but photographs should be treated solely as a source of valuable information and not just as images to be reproduced uncritically. It is also worthwhile concentrating on some of the practical aspects of the depiction process: to draw the movements you see without worrying too much about what your drawing looks like or how scientifically accurate it is; to simplify the forms and to seek out the lines of direction that best express the feeling and direction of motion; to work with full and concise, summarising pencil strokes; to concentrate on the flow-lines and on the body's main axes; to try to suggest the figure's forms rather than define them and to avoid reproducing 'known' details (details that you know are there but that are impossible to perceive at a glance) at the expense of the overall form. Sketching entails the need to work in an unfinished, but not sloppy, way.

As sketching is, by definition, performed quickly, succinctly and in 'real time', it is difficult to break the sketching process down into distinct successive stages of execution. Nonetheless, you have to start somewhere when you make your marks on the paper:

a If you are dealing, for example, with the whole figure (whether clothed or naked), you could begin with a quick, light line to mark out the space that the figure will occupy on the page of your sketchpad (maximum height, maximum width, and so on). This could be followed by hinting at the main divisions of the body (head, torso, limbs) and their proportional relationships to each other. You could finish by defining the most important profiles, the areas of shade and details that cannot be omitted.

b It is possible to follow a similar sequence when drawing just the head, moving from the general elements to the specifics or, once you have worked out the overall space it will take up on the page, you could then move on to defining the dimensions and the form of an important detail (an eye, the nose, etc.). Move from this to constructing the entire head and the relationships of each part to another, moving from specifics to the general elements.

The choice of which of these two approaches to adopt will depend on the artist's attitude and preferences, but also on the position in which they find the subject they intend to sketch.

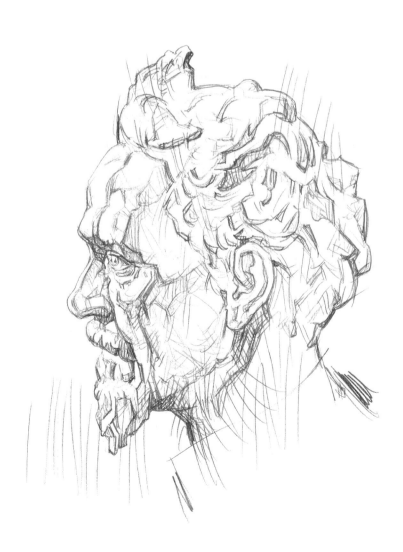

A REPERTOIRE OF FACES

When making life drawings of the heads or faces of people you do not know – even when sketching them quickly – it is important to remember that we must respect the privacy of people who have not given their consent to be used as models. Of course, this is not a full portrait that you are drawing, just a study of structure or of expression. Nonetheless, if the drawing is well executed, a resemblance will be captured and this may be against the wishes of the person concerned, should it so happen that the sketch is later shown in public. Even though this may be an unlikely event, make your intentions known to the person concerned and ask for their consent, in the light of possible subsequent developments. Having done so, you can work with greater peace of mind. In most cases, however, you will be busy contending with the extremely mobile nature of people's expressions and the way that heads can move so quickly; learning to work, in other words, in the full knowledge that the sketch you are making may have to be interrupted at

any moment and at any stage of completion. For these reasons, try to choose situations in which you can reasonably expect at least a few moments of relative stillness (in restaurants, waiting rooms, parks, etc.), and learn to get the essential features down on paper quickly, keeping them constantly updated in your mind so that you are able to complete the sketch even after the model has walked away and left. If you have the time, and the opportunity presents itself, draw the head from different viewpoints and, if possible, analyse some of its details. I sketched the Asian-looking man, shown opposite, during a visit to an art exhibition while he was engrossed in studying a sculpture. The men in uniform were drawn at an historic commemoration. Such occasions make excellent opportunities to find people dressed up in picturesque, antique military uniforms. The participants often have a real air about them of being 'perfectly posed', as if they are just waiting for sketchers and photographers to come along (see also pages 31 and 32).

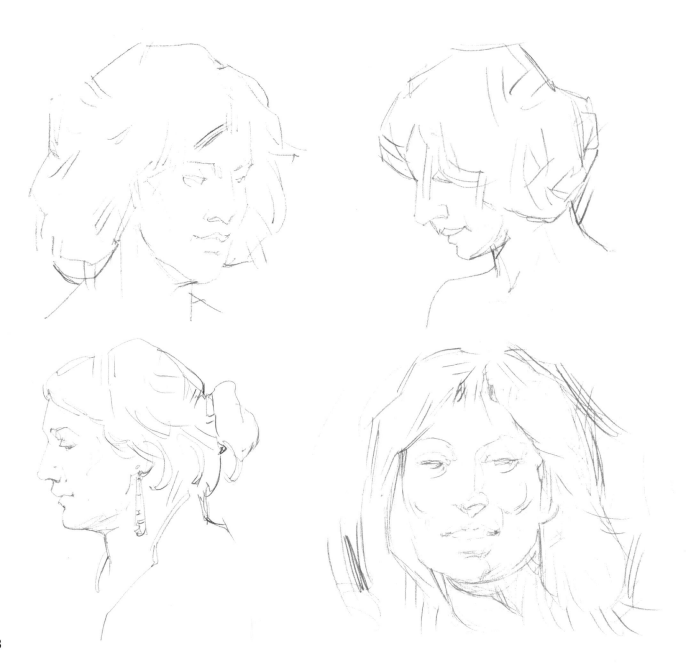

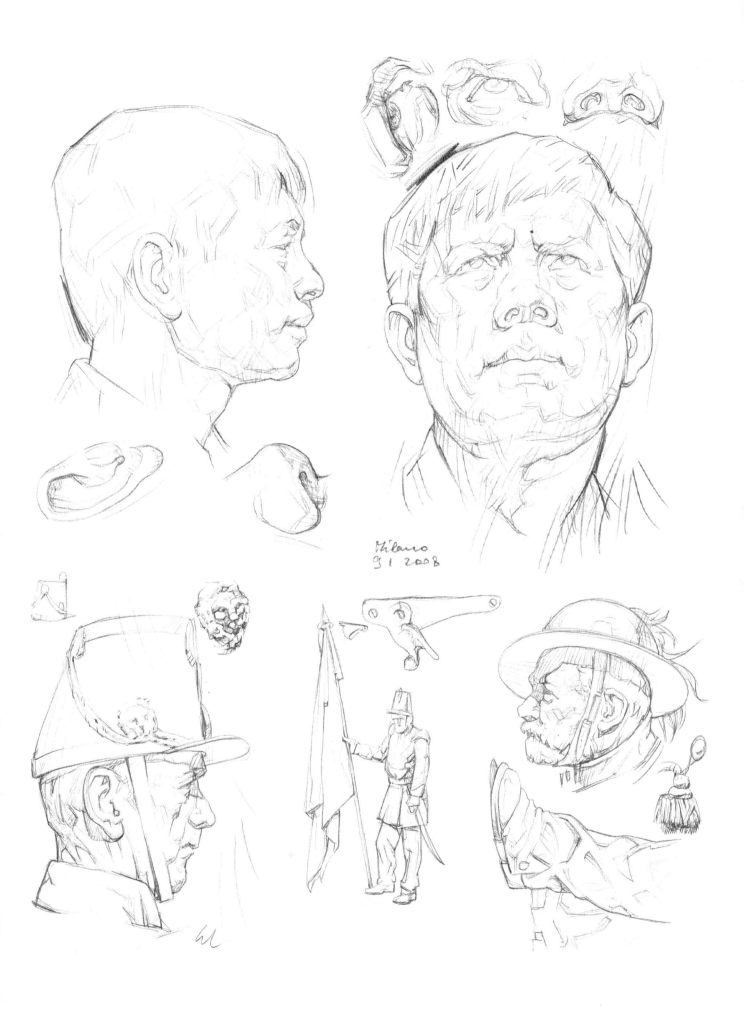

Milano
9 I 2008

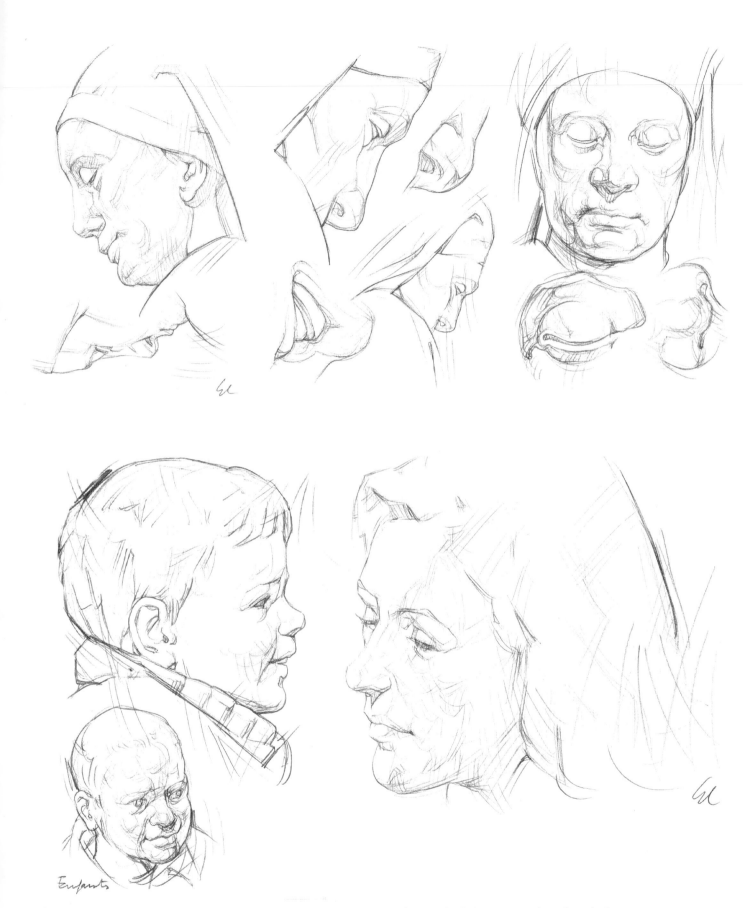

The nurse (top left) was so focused on her task of applying a dressing that she appeared almost immobilised and statue-like. This provided me with a rare opportunity to make an unhurried study of her face and of some of its more interesting details. Children, by contrast, are terrifically full of life and can only be sketched in a summary and impressionistic way, working largely from memory. Photographs may seem to offer a solution to this problem, but using them results in drawings in which immediacy is subdued when compared with those done 'in the field' (see page 20).

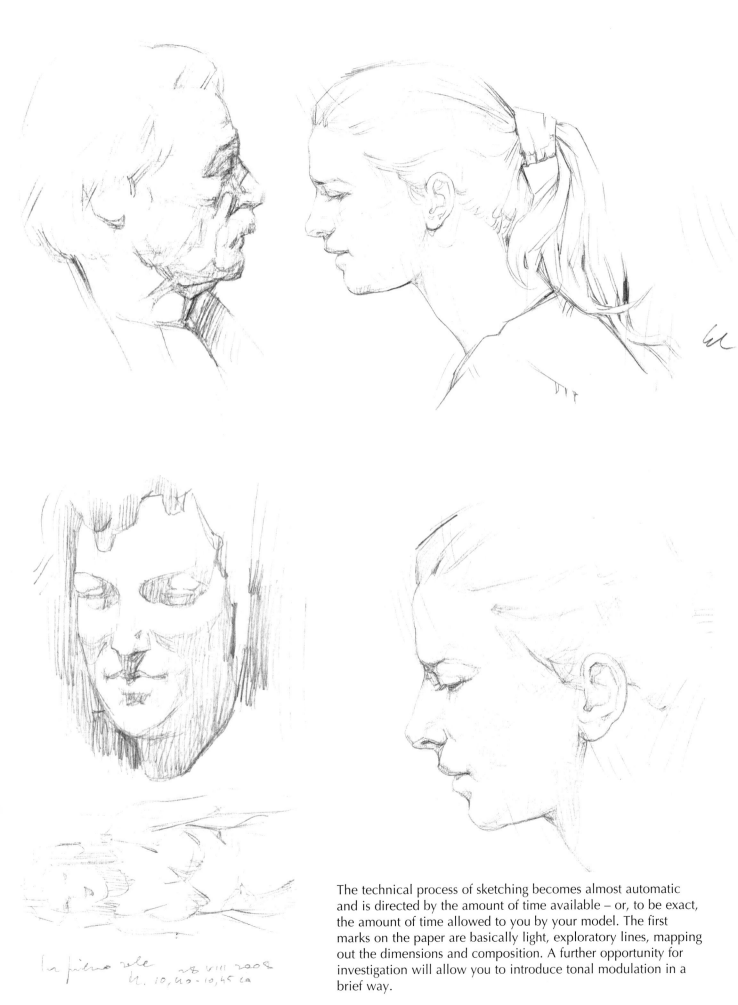

The technical process of sketching becomes almost automatic and is directed by the amount of time available – or, to be exact, the amount of time allowed to you by your model. The first marks on the paper are basically light, exploratory lines, mapping out the dimensions and composition. A further opportunity for investigation will allow you to introduce tonal modulation in a brief way.

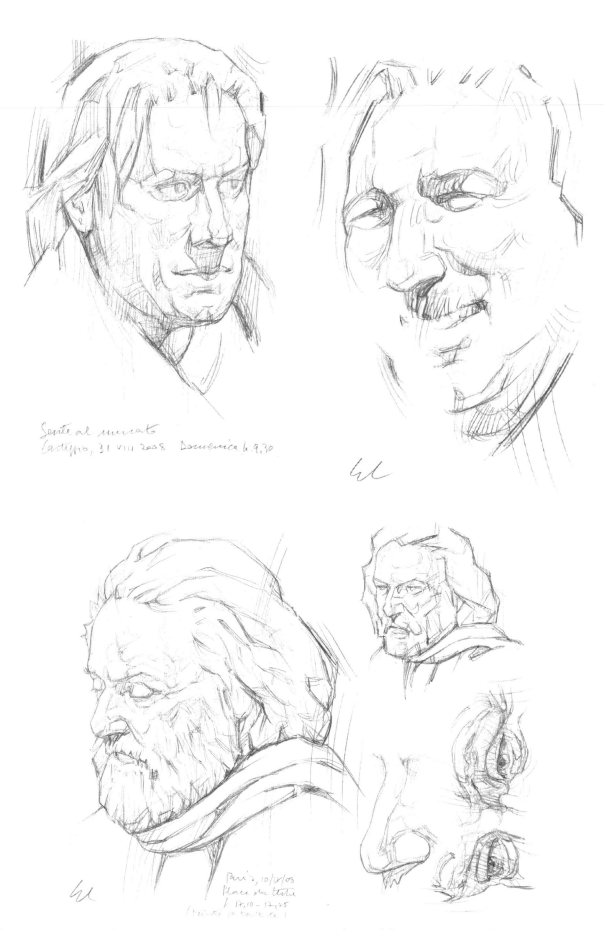

Sente al mercato
Castigno, 31 VIII 2008 Domenica h.9.30

Paris, 10/IX/08
Place du tertre
17,10 - 17,25

The faces you see reproduced on this and the following pages (pages 12–18) were drawn during recent stays in Paris. The Place du Tertre, in Montmartre, is an ideal spot for sketching figures, but it is an especially good source of faces as it is constantly visited by a great number of people who wander through the alleyways, stopping in front of the street artists who set up their easels in the square each day. These artists themselves make ideal subjects, but a lot of the tourists also sit for on-the-spot portraits, which enabled me to make my own sketches of them, positioning myself beside or behind the shoulder of the actual portraitist.

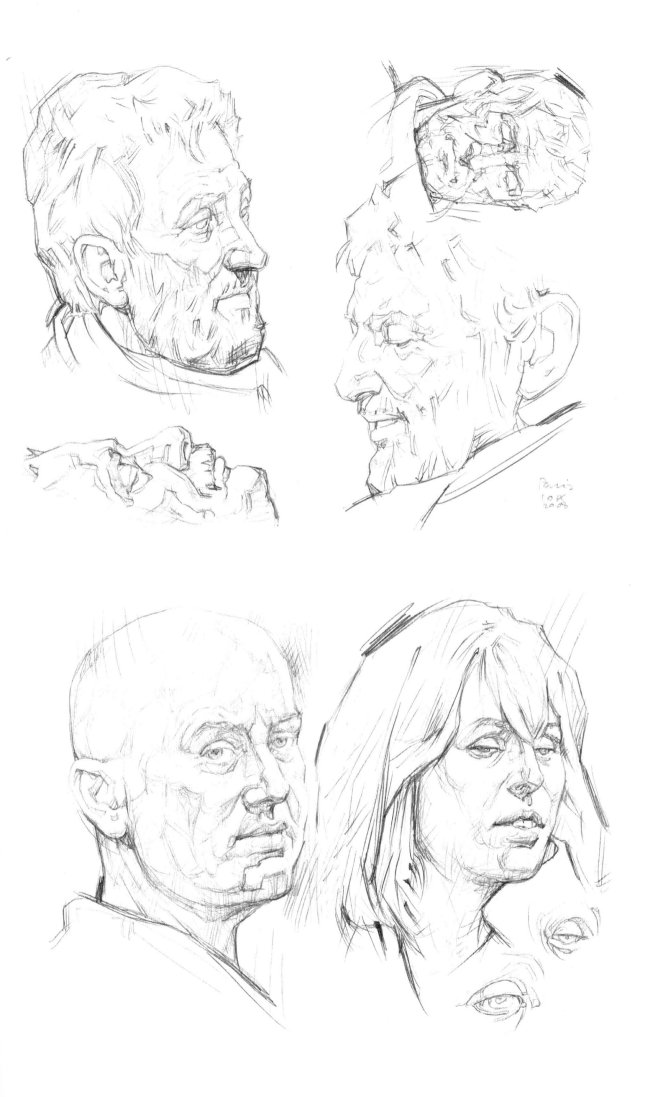

13

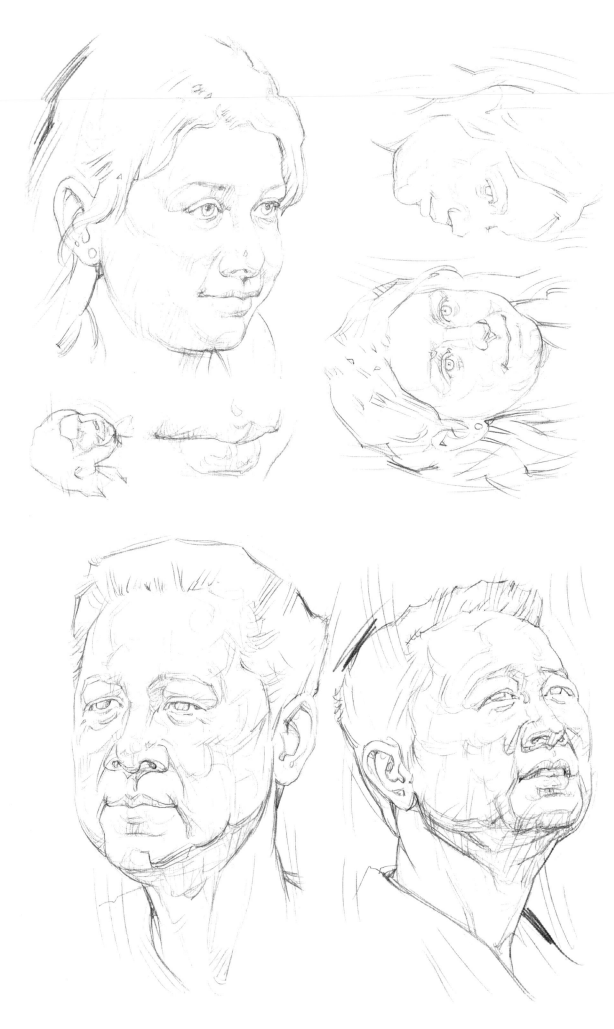

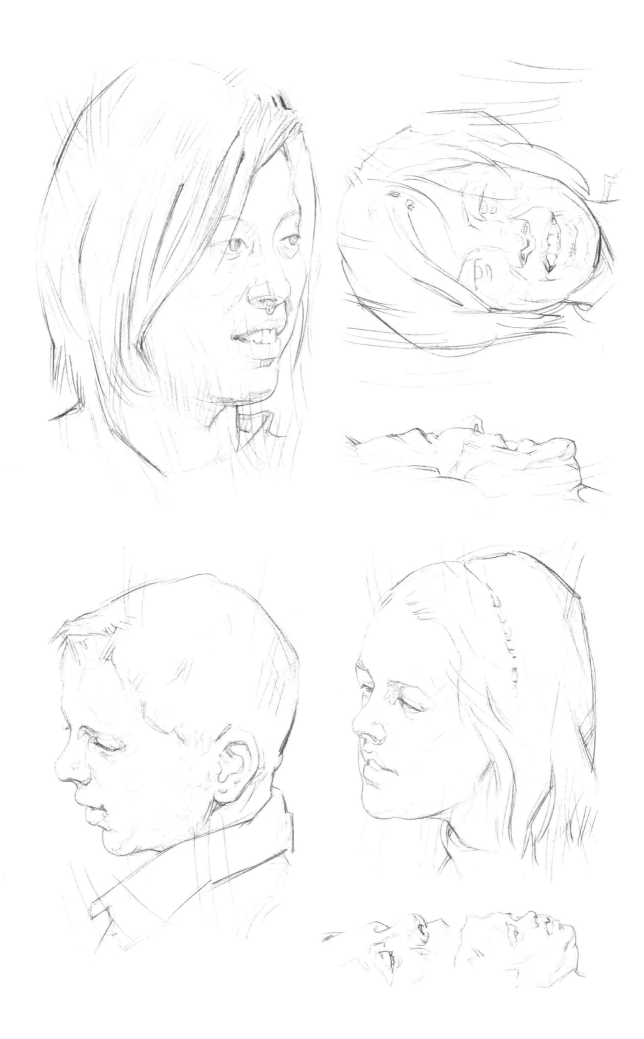

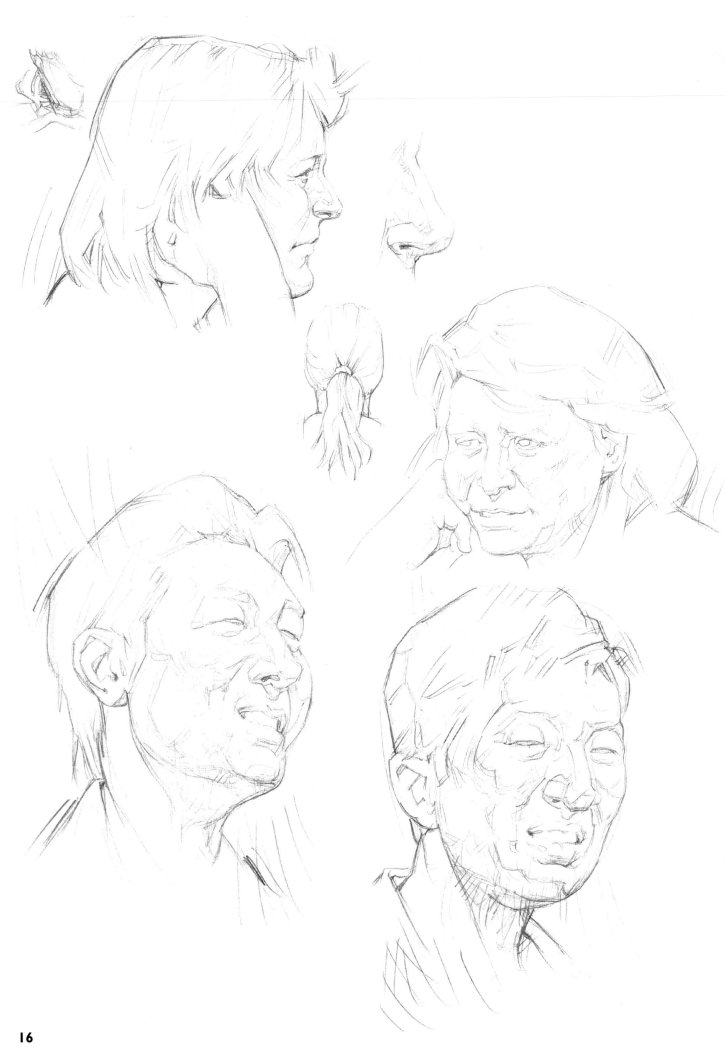

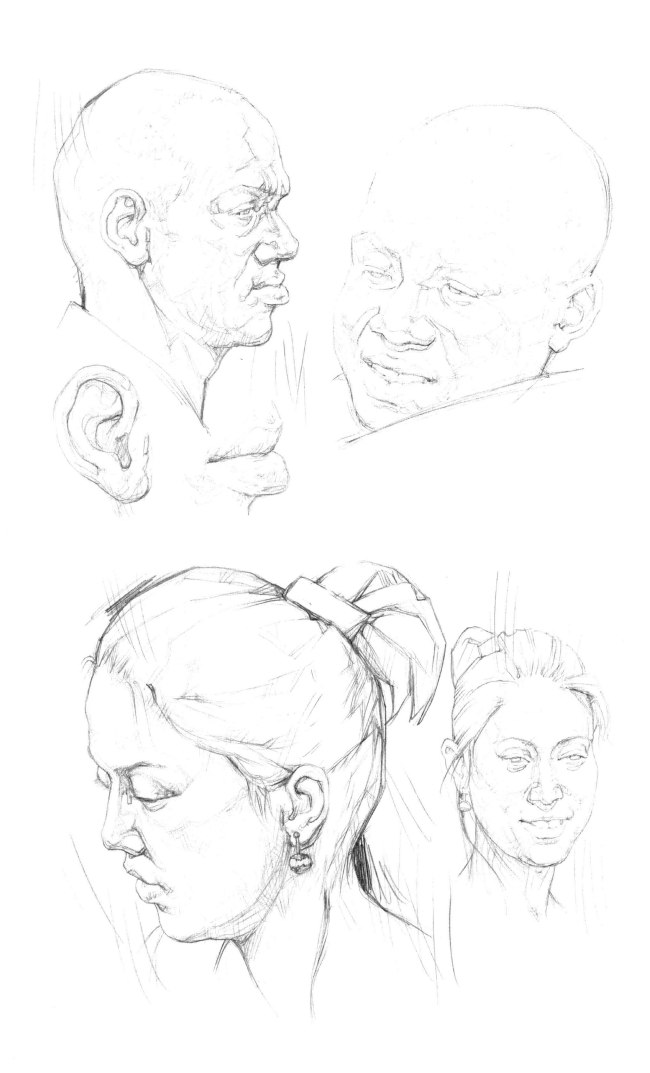

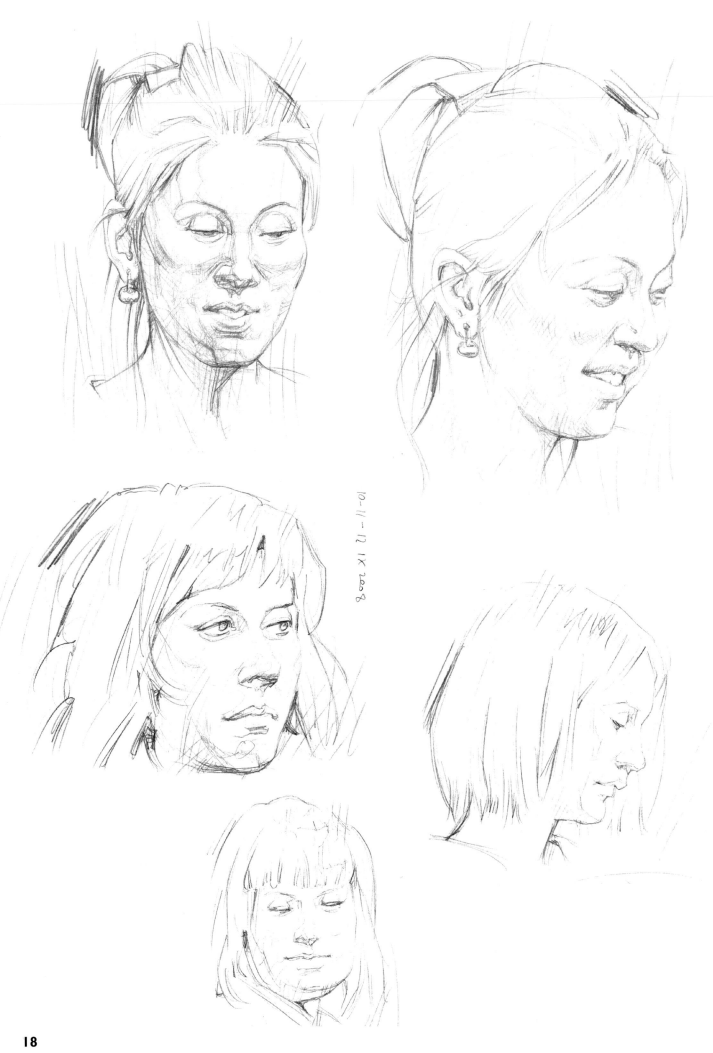

2008 IX 11–12 10-11-01

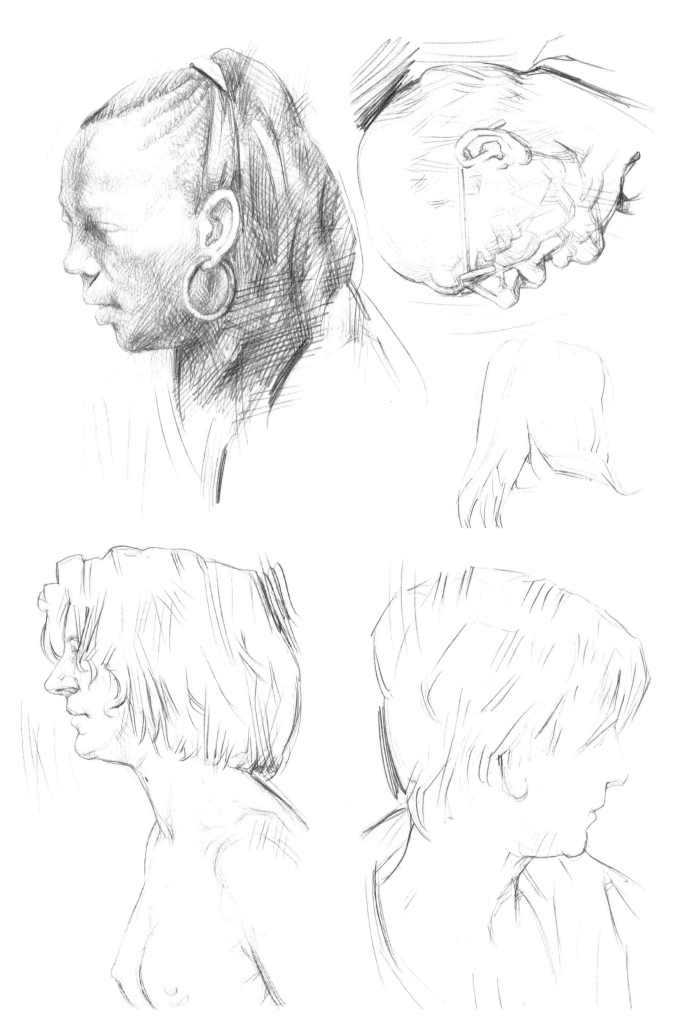

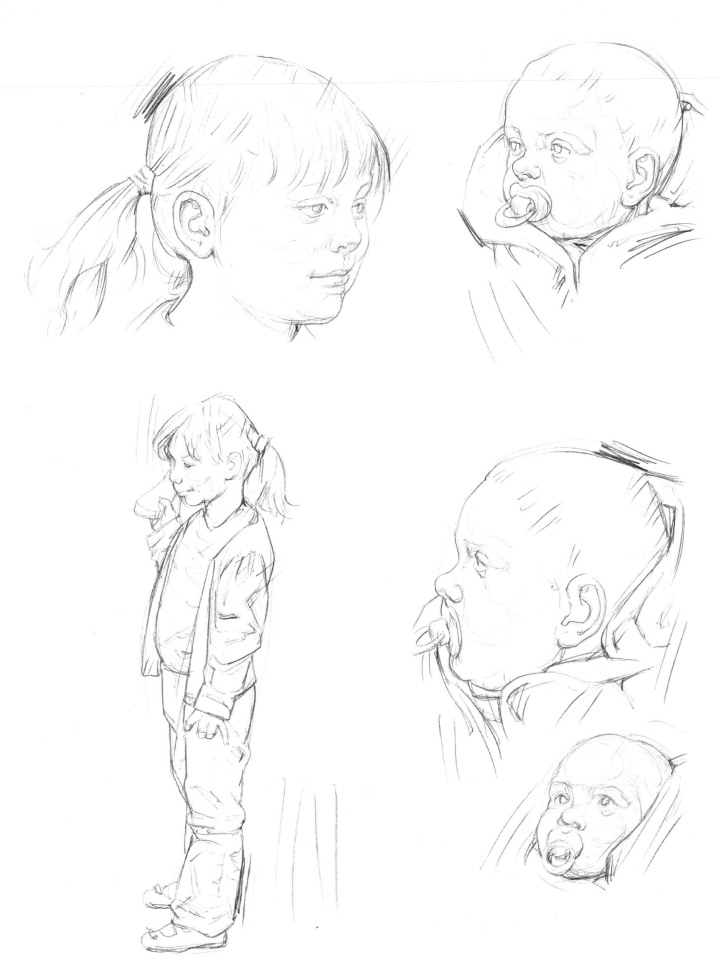

There is no rule that the models for your sketches have to be strangers. An understanding and a willingness to oblige may be found quite easily in your circle of close friends – well, for a little while, anyway…

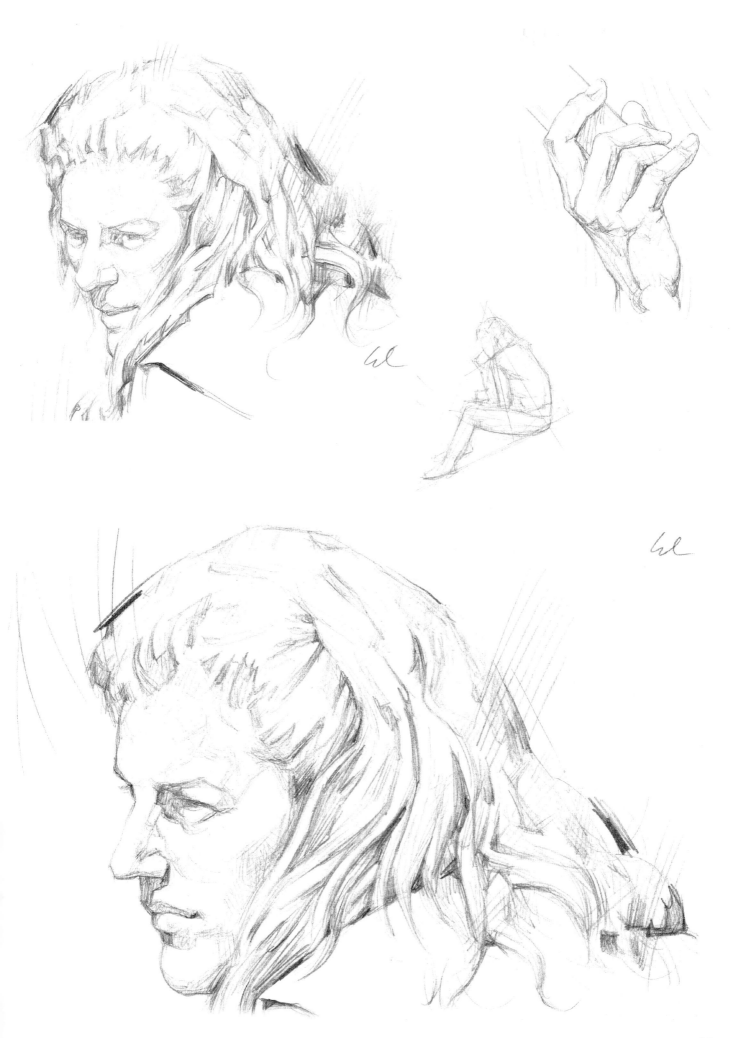

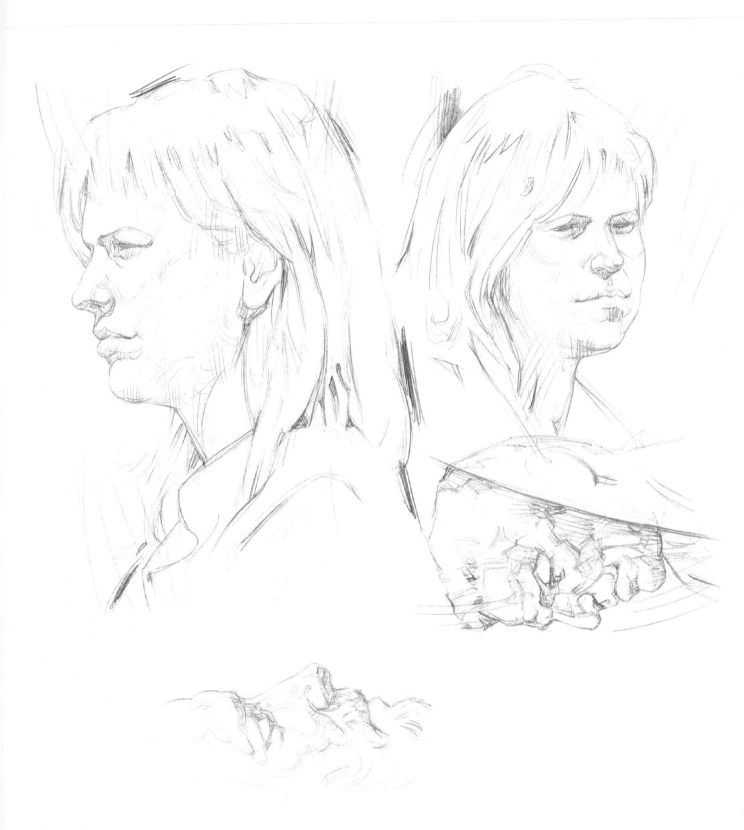

These subjects were sketched in Milan's Giardini Pubblici (a large park in the centre of Milan). The spring sun encourages people to laze for a while in such places. They are also full of children running about and playing, but it is much easier (using a little stealth) to draw their mothers, or the people charged with looking after the children. They move about far less and their attentive gazes give rise to interesting expressions and stances. Unfortunately, even in such peaceful environments, opportunities to develop drawings further are rare, and you have to content yourself with sketches made up of just lines or a few areas of shading. Frequently practising sketching will quickly give you confidence in picking out just the essential elements.

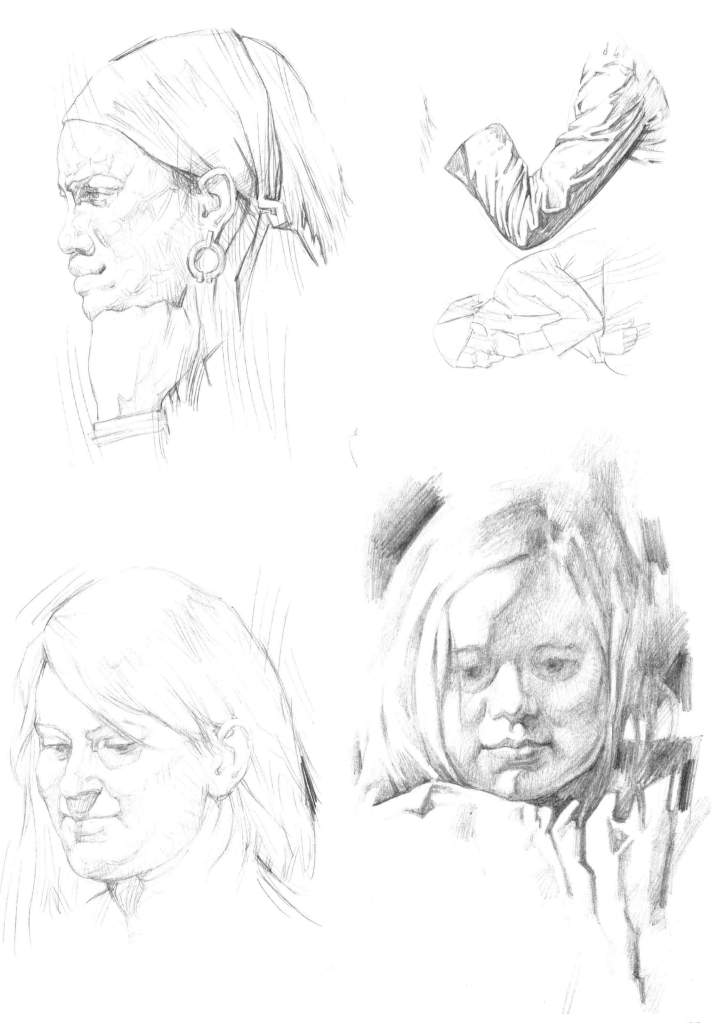

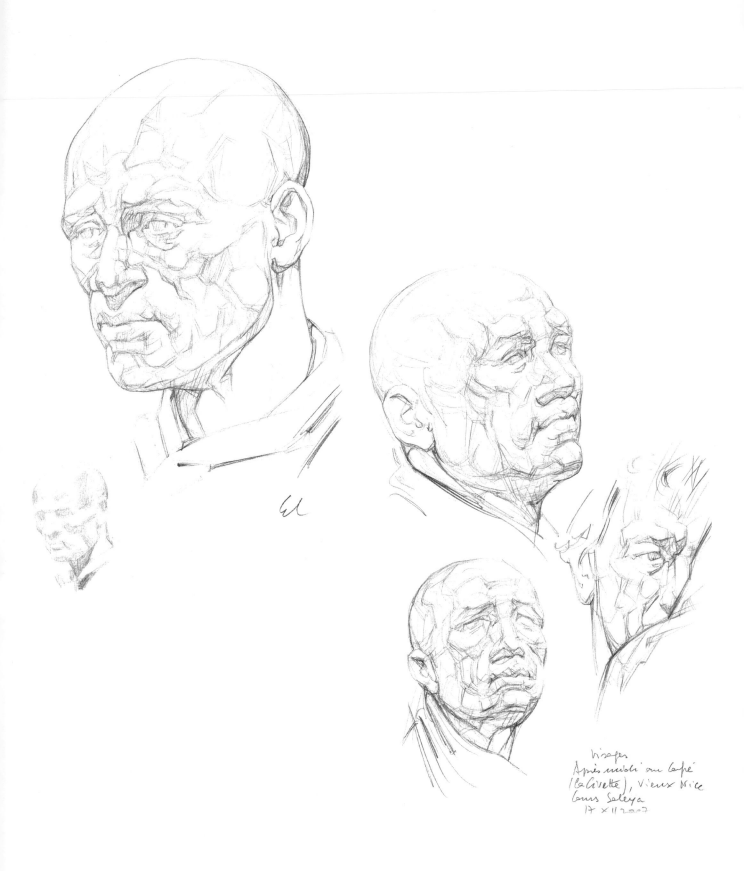

These drawings show how the outcome of your sketch is determined by the amount of time your unknowing model grants you. On this page you can see a sketch of a head that I was able to bring to a sufficient level of elaboration: I managed, at least, to outline and investigate the modelled surface of the skeletal structure, the play of the musculature and also to indicate the areas of shade belonging to each muscle. At this point, the 'model' was seated at a café table and concentrating on reading a newspaper. Opposite, the same person started assuming ever more fleeting positions until I could do little more than jot down construction-line layouts of the overall form of his head.

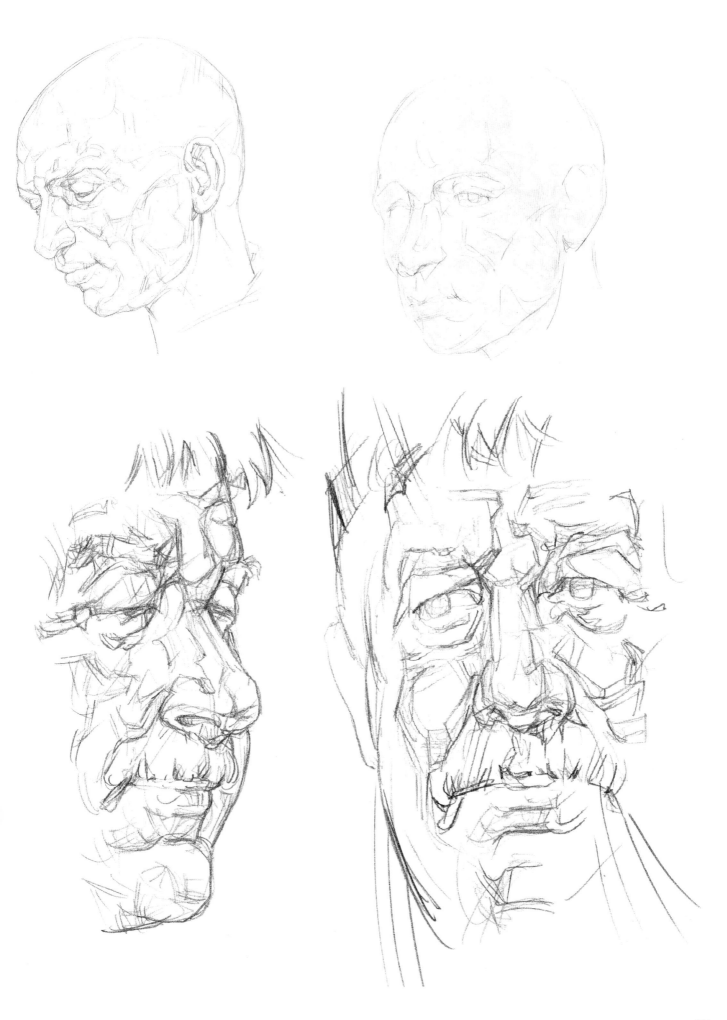

A REPERTOIRE OF FIGURES

Sketching figures is more difficult than sketching faces and yet, at the same time, it is noticeably simpler. The difficulty is due to the structural complexity of the figure as a whole (added to which, figures are almost invariably covered by clothing) and to the larger scope of bodily movements. It is simpler because of the way posture can be read immediately and because of the way that points of interest are scattered about (we are interested not just in the face, but in the torso, the limbs, the folds in the clothing, etc.), which means we do not need to analyse individual details quite so closely. Many of the more appealing body positions that seem most suited for sketching are over too quickly for them to be noted down directly in real time, even with a few strokes. Rather than falling back on the use of photography, the problem can be solved by stepping up your concentration levels and frequency of practice, as well as by making greater use of your visual memory (see pages 28, 29, 34 and 43 for examples). Constant practice will, in a short while, bring proficiency in the skill of summarising the gist of what you see and depicting it effectively. When a position is held by your 'model' for longer, you may have enough time to make a fairly elaborate sketch, which, with luck, may be repeated from different viewpoints (see pages 31, 37 and 38 for examples).

Sometimes the person concerned knowingly gives their consent to be portrayed and so sketches can be done quite unhurriedly and develop from an impromptu sketch to an in-depth study (see pages 33, 35 and 36 for examples).

The sketches reproduced in this section were made at different times and in different places (on the streets, in museums, on the beach, etc.) and under the most varied conditions. These circumstances are, I hope, evident in the sketches themselves. I have arranged them in assorted groups without any commentary, simply so that they may convey some idea of the wide range of opportunities that exist for observation and the variety of results that can be achieved.

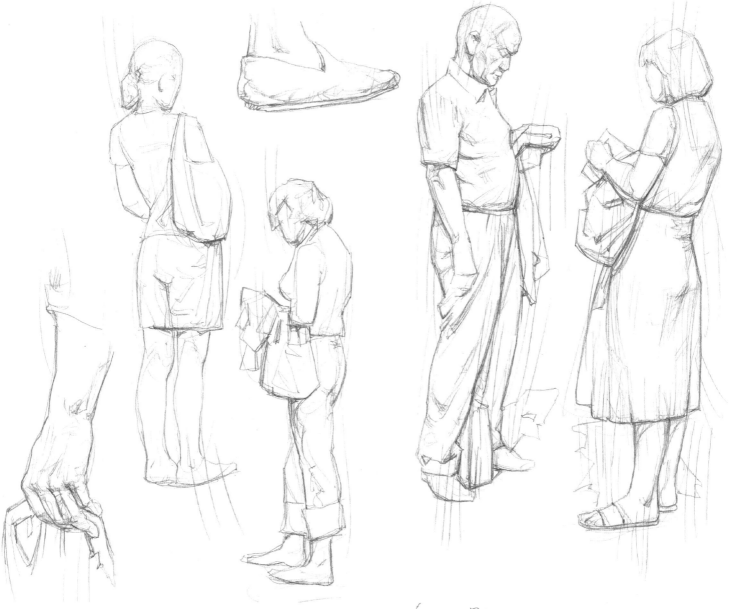

conversation, 23 VII 2008

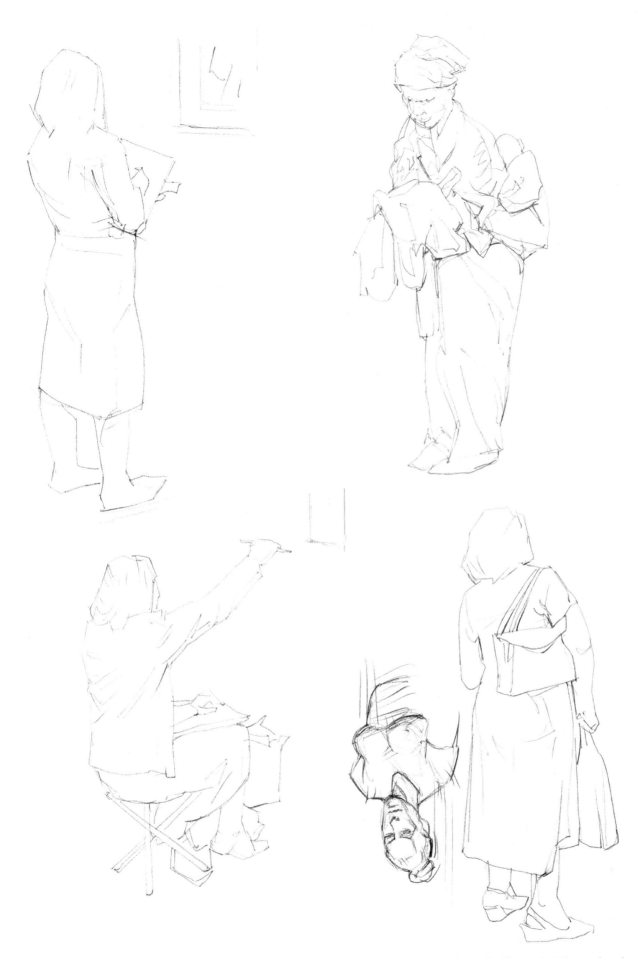

An almost indistinct light line, produced by skimming the pencil across the surface of the paper so that it barely touches it, is sufficient to render the essential elements of the scene simply and effectively. These sketches were made in no more than two minutes.

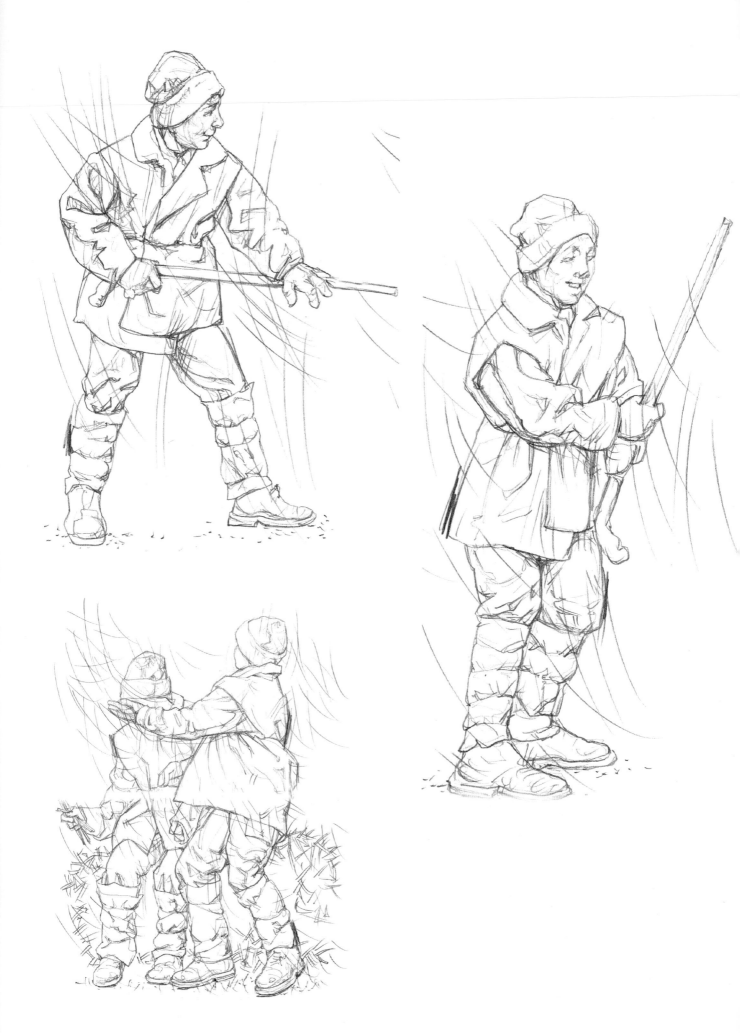

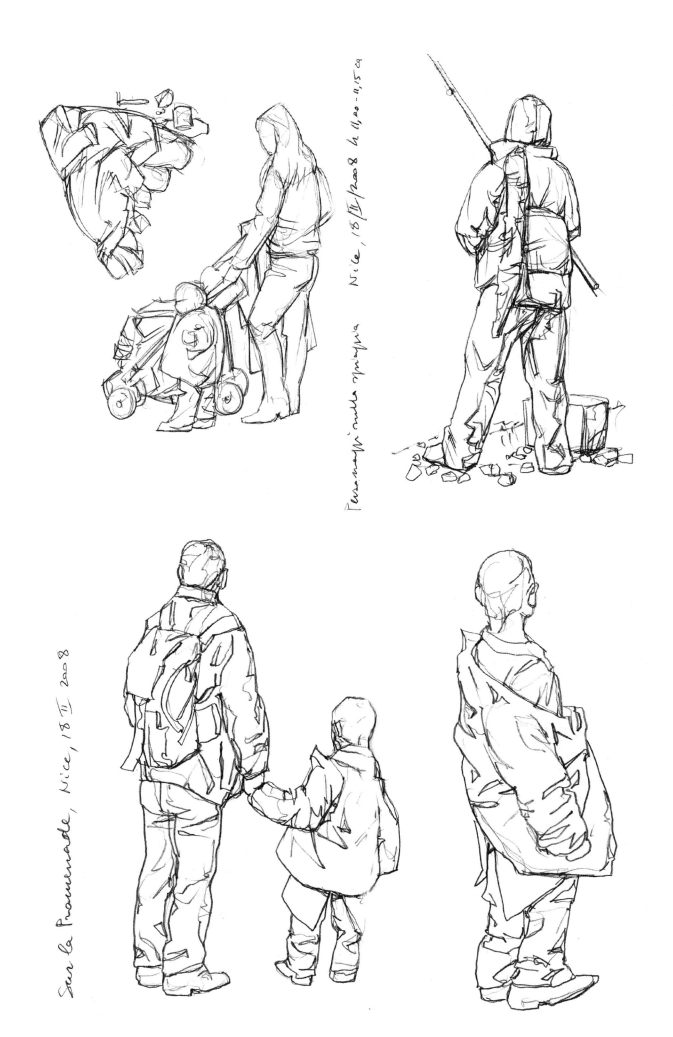

Nice, 18/IV/2008 h 11,20 - 11,15 ca

Personaggio sulla spiaggia

Sur la Promenade, Nice, 18 IV 2008

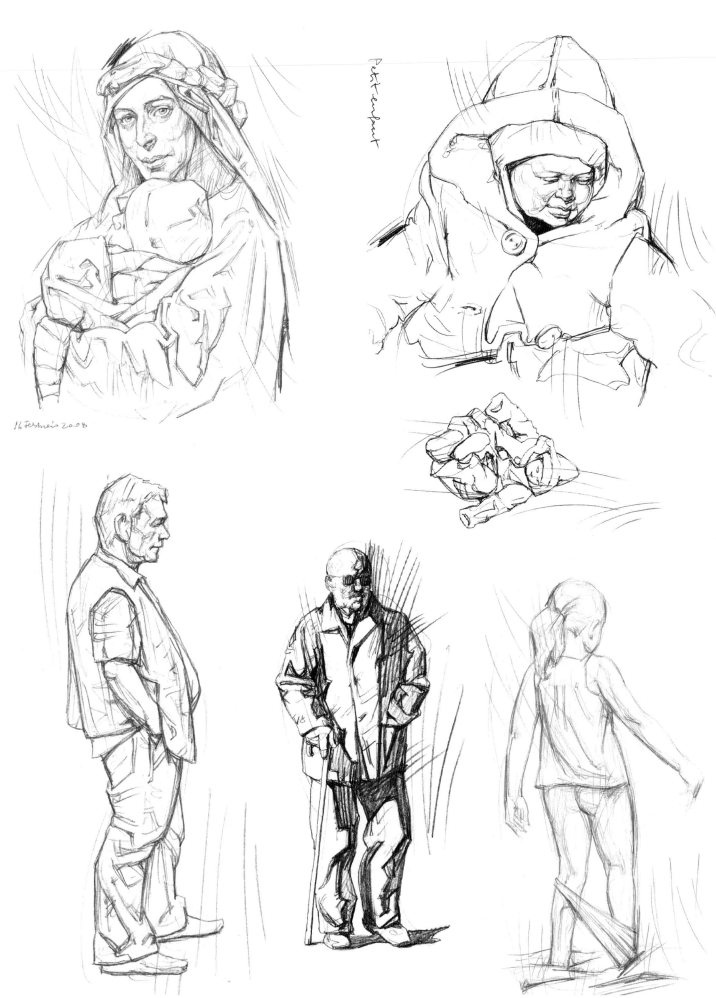

16 Februeis 2008

Petit enfant

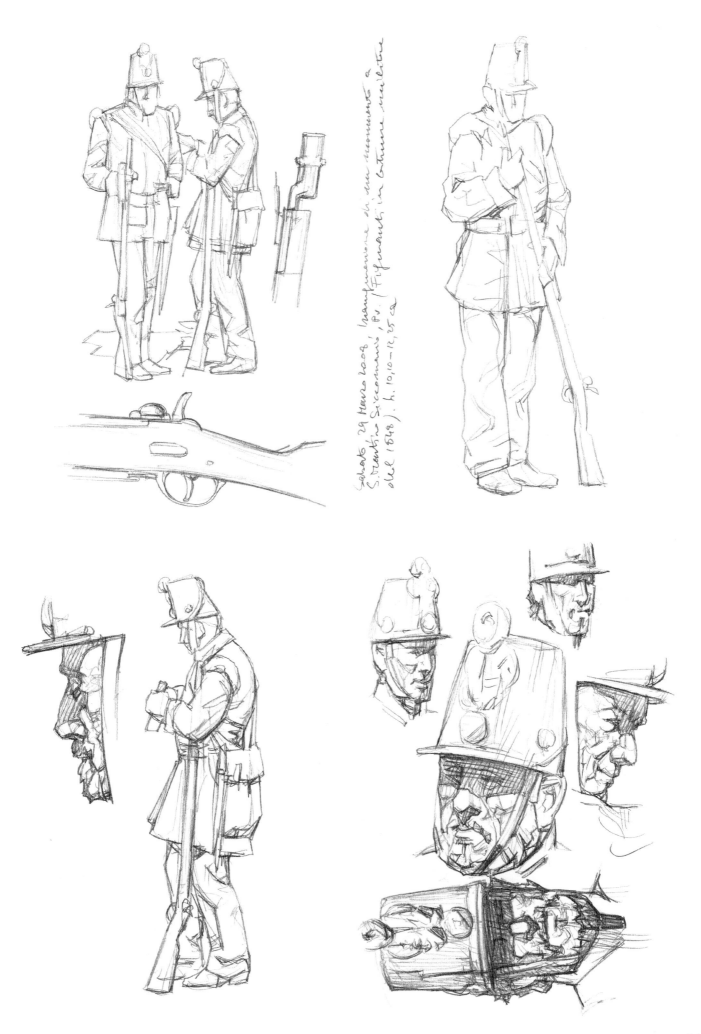

Sabato 29 Marzo 2008. Manipulare di un ragazzo a
S. Martin Siccomani, Pr. (Figuranti in costume militare
del 1848). h. 10,10 - 12,25 a

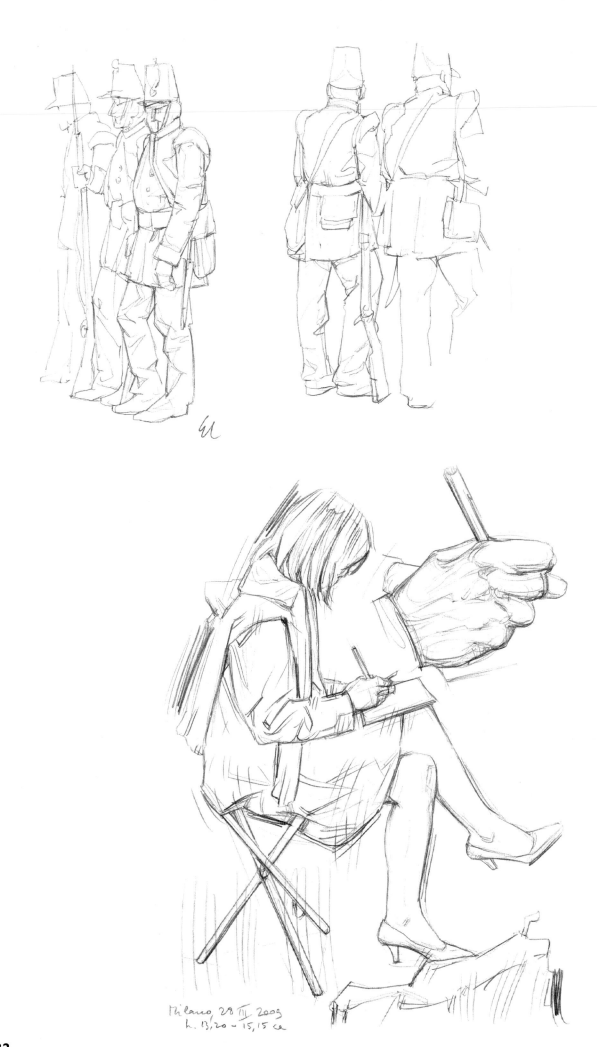

Milano, 28 III 2009
h. 13,20 - 15,15 ca

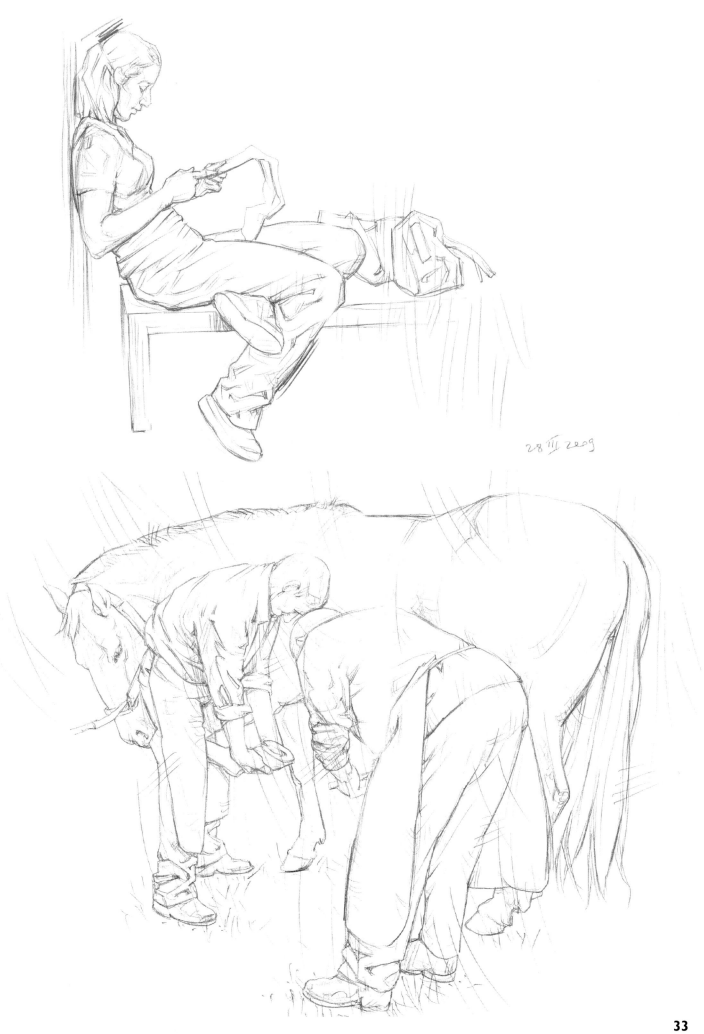

28 III 2009

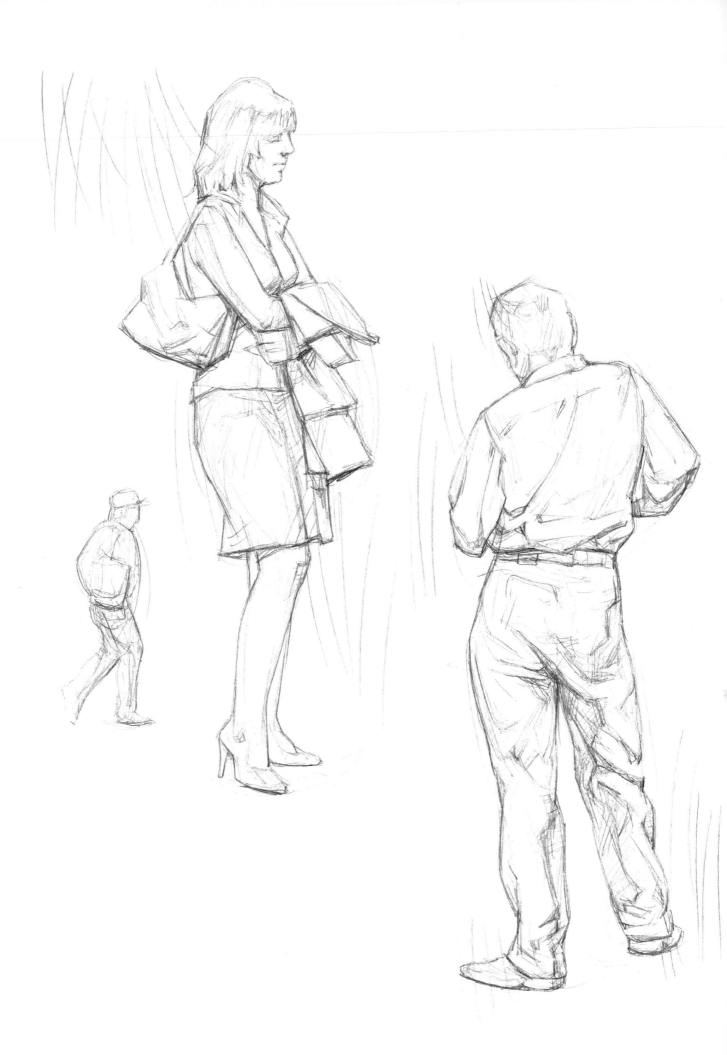

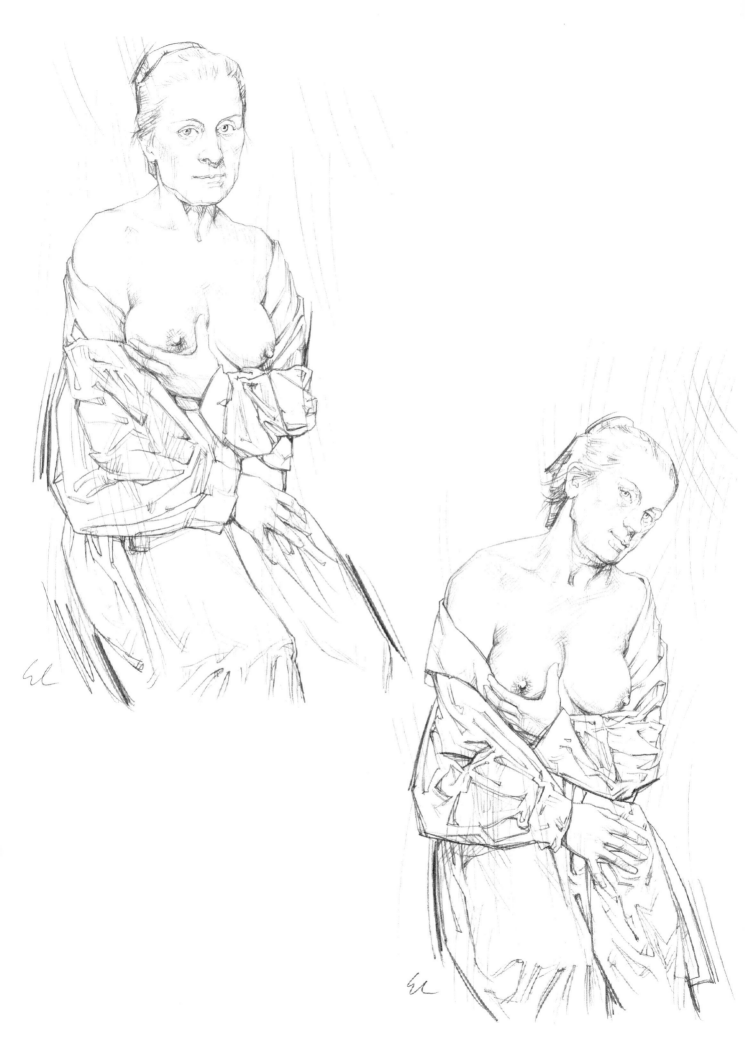

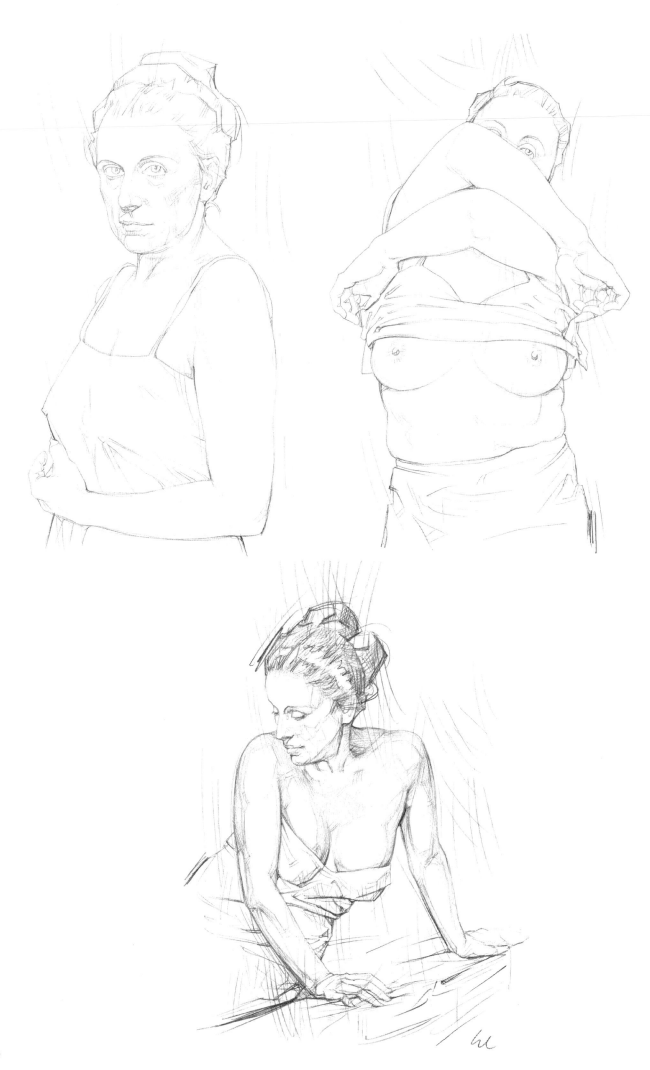

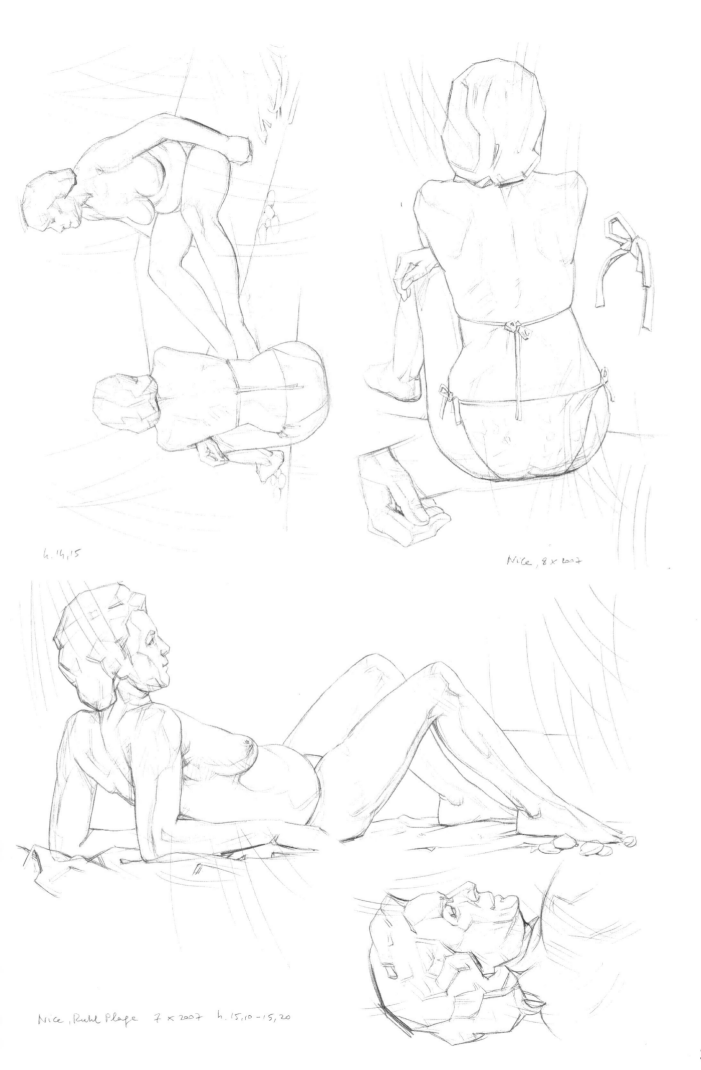

h. 14,15

Nice, Ruhl Plage 7 x 2007 h. 15,10 – 15,20

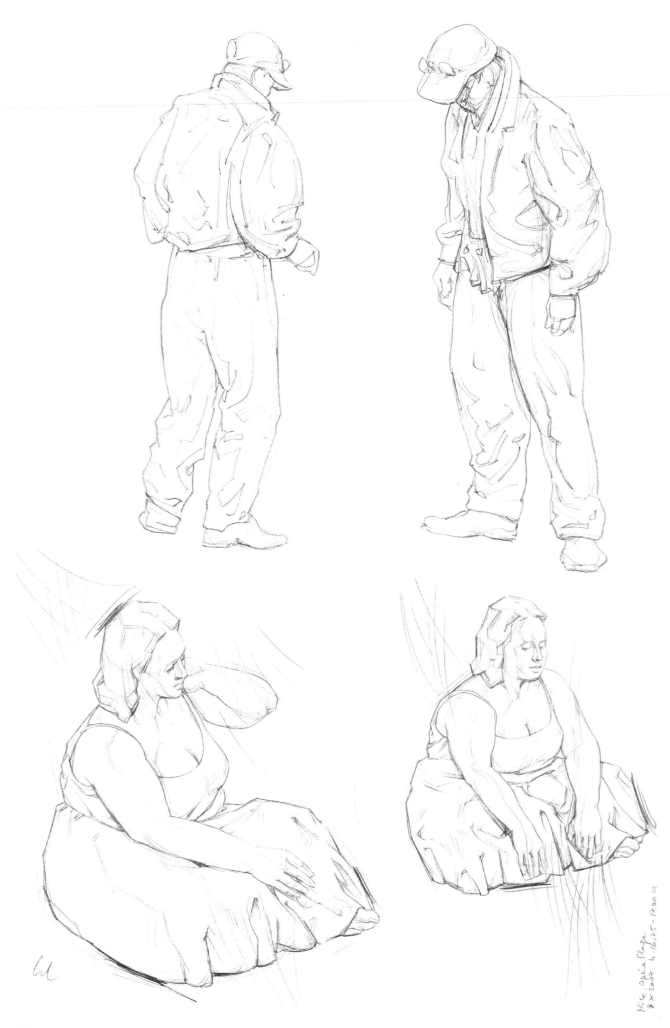

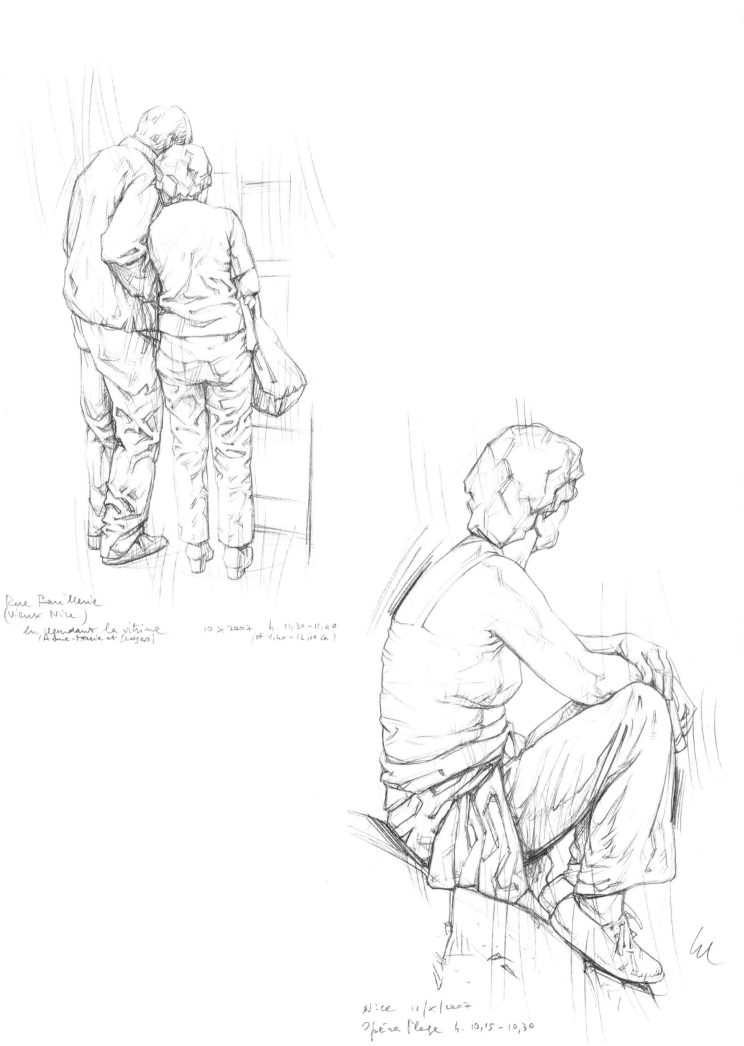

Rue Barillerie
(Vieux Nice)
En regardant la vitrine
(Anne-Marie et Jacques)

10 X 2007 h. 11,30 - 11,40
 (et 11,40 - 12,10 (a)

Nice 11/X/2007
Opéra Plage h. 10,15 - 10,30

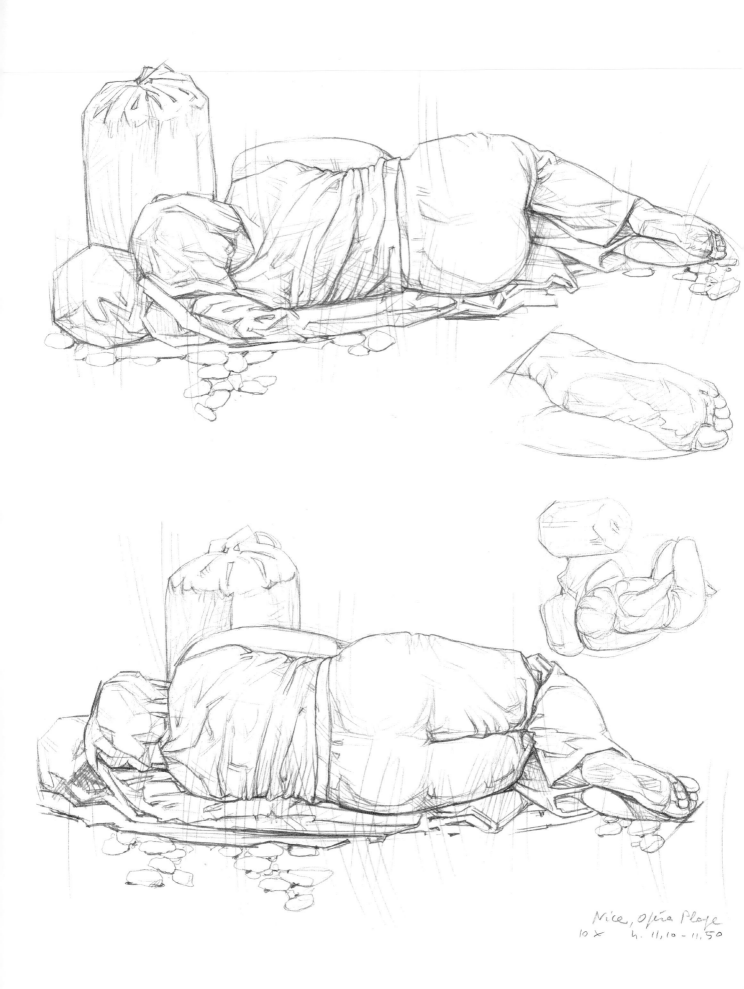

Nice, Opéra Plage
10 X h. 11,10 - 11,50

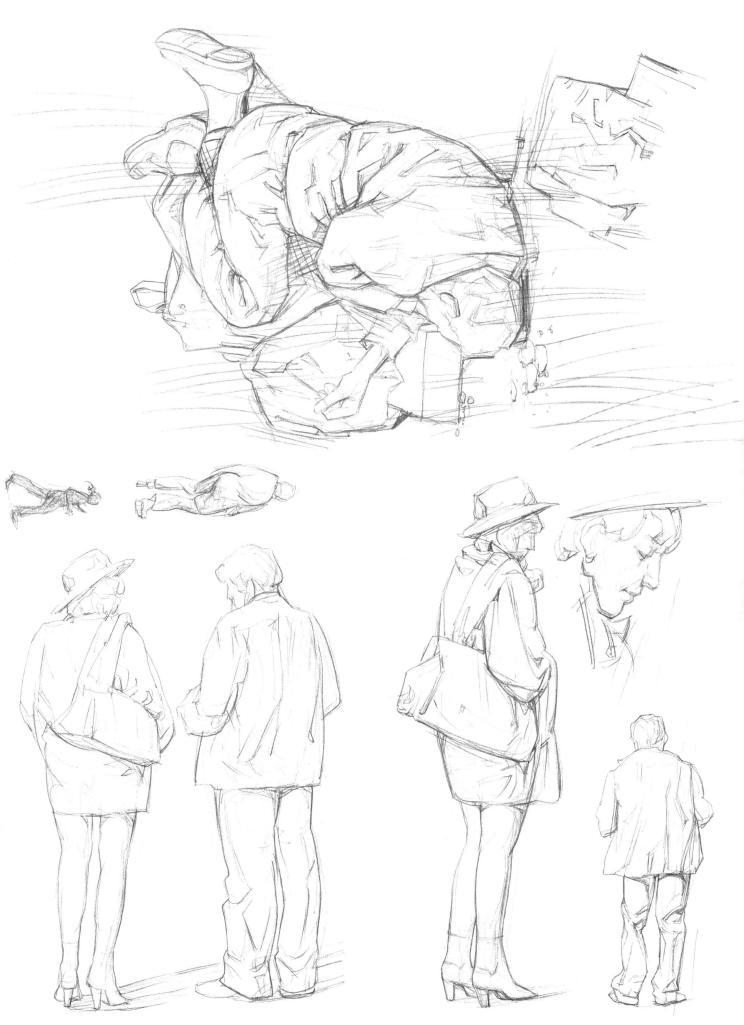

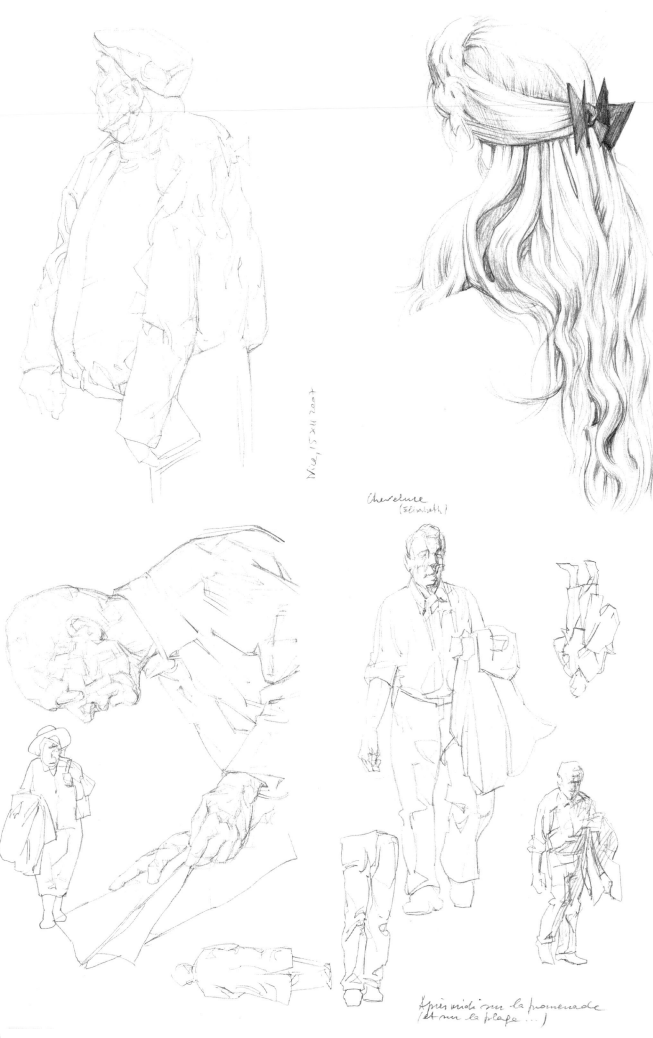

Nice, 15 XII 2004

Chevelure
(Elisabeth)

Après midi sur la promenade
(et sur la plage ...)

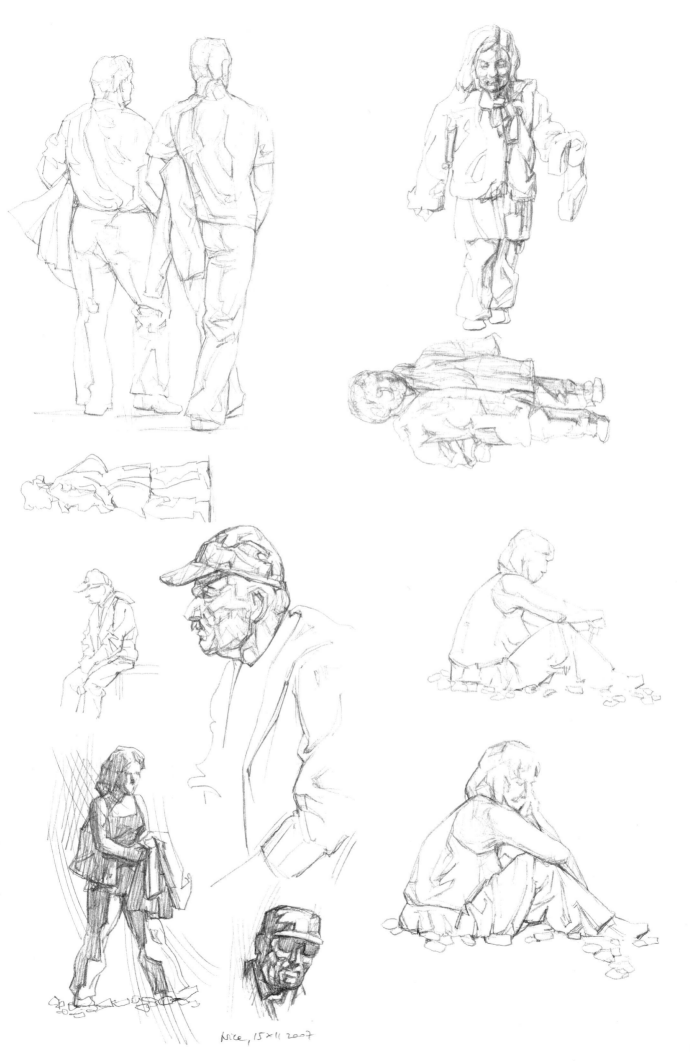

Nice, 15×11 2007

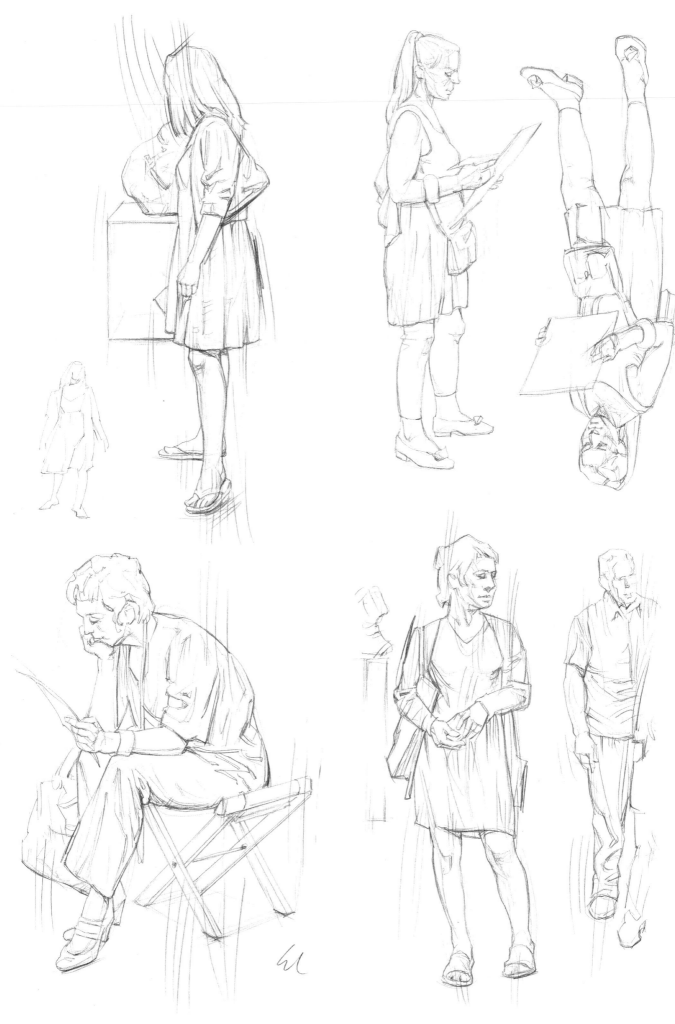

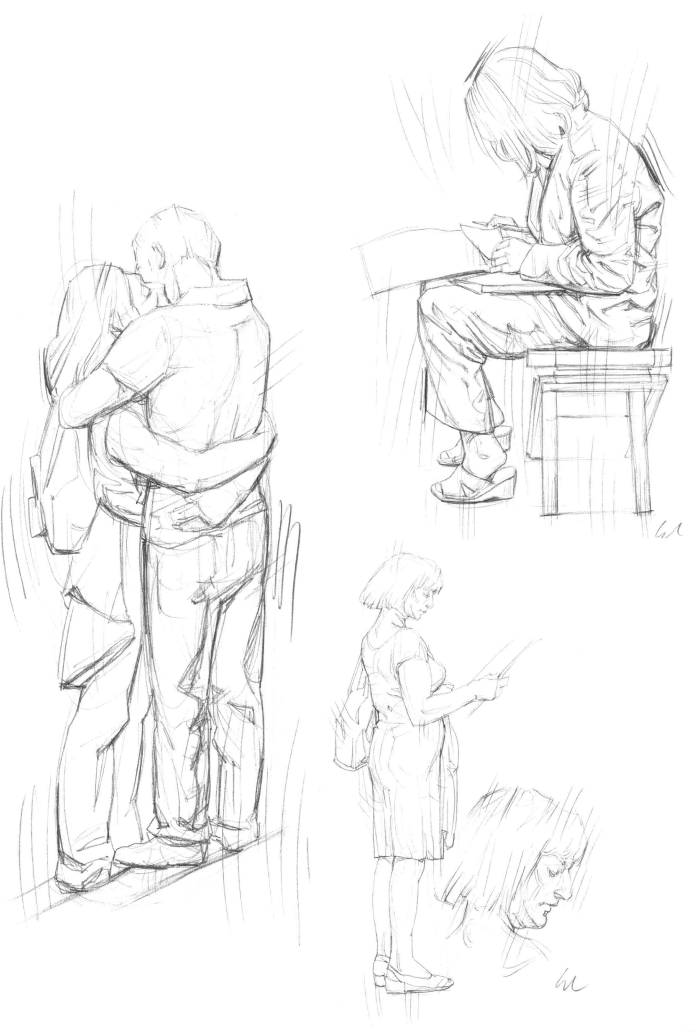

DRAWING STATUES: SCULPTURES FROM THE MUSÉE RODIN, PARIS

I have already laid out some of the reasons why you might choose to begin by drawing sculptures before moving on to tackle sketches from life (see page 6). It is obvious that a 'model' that stays still permits you to work calmly, attentively and comfortably. In addition, a sketch from life contains a much higher risk (for example of not being finished, failure, being interrupted, etc.), than the carefully thought-out and prolonged study of an immobile subject. In fact, this is why the constant practice of sketching is so important. The training it provides will enable you to make split-second, precise observation; it helps you to understand what you see and grasp the gist of a scene quickly; it develops sureness of hand, an eye for composition and ability in depiction.

In common with many other artists, my aesthetic preferences have led me to choose the Rodin Museum as a place for my personal training. The statues of this great sculptor offer unique and fascinating opportunities for analysis of anatomy, composition and proportion, and for observation of surface modulation. Furthermore, in this museum the statues are well placed and well lit (some of them have been positioned in an adjacent garden), and they may be studied with ease from various distances and viewpoints. The practice of drawing from works of art is a very profitable one for acquiring technical training and mastery of your craft, as well as for refining your artistic and critical sensibilities.

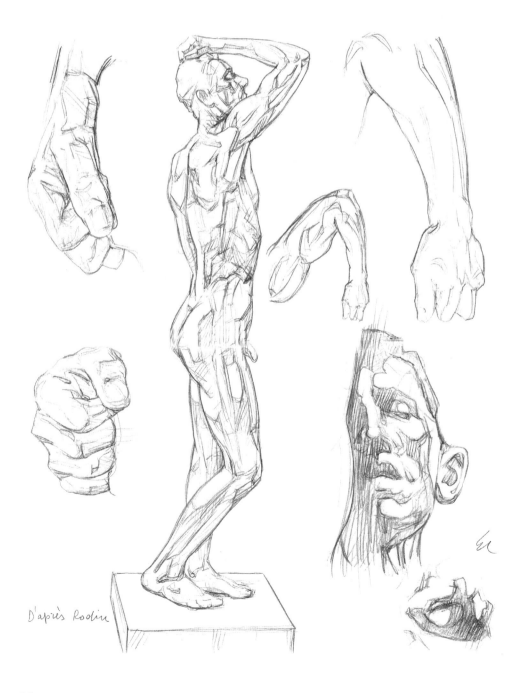

The Age of Bronze (1876)
Bronze, 181cm (71in) high

D'après Rodin

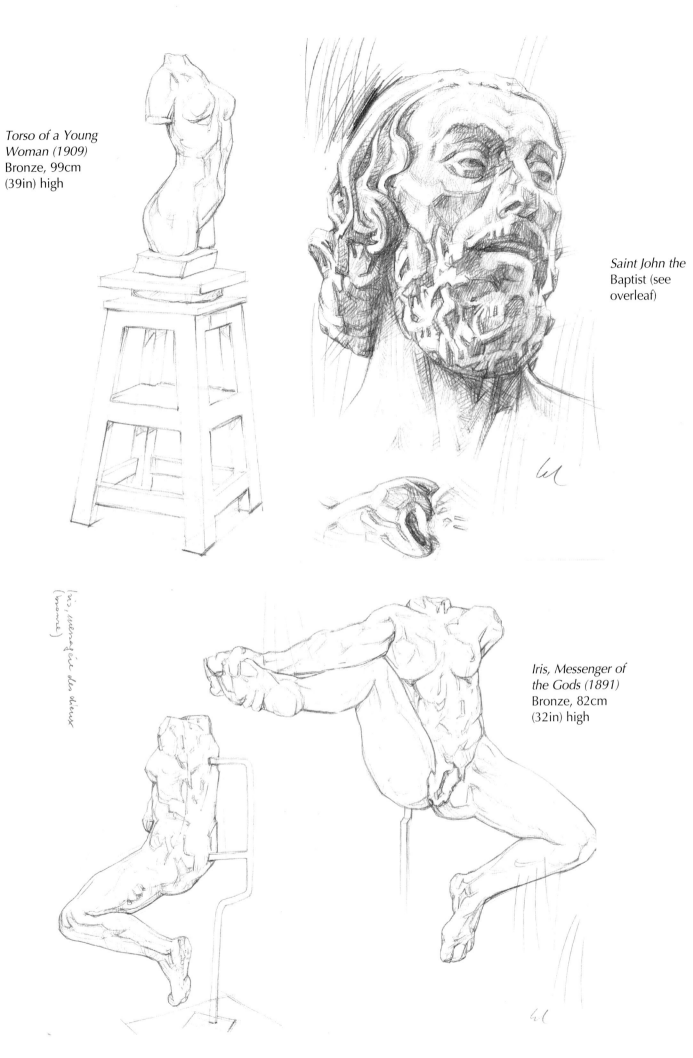

Torso of a Young Woman (1909) Bronze, 99cm (39in) high

Saint John the Baptist (see overleaf)

Iris, Messenger of the Gods (1891) Bronze, 82cm (32in) high

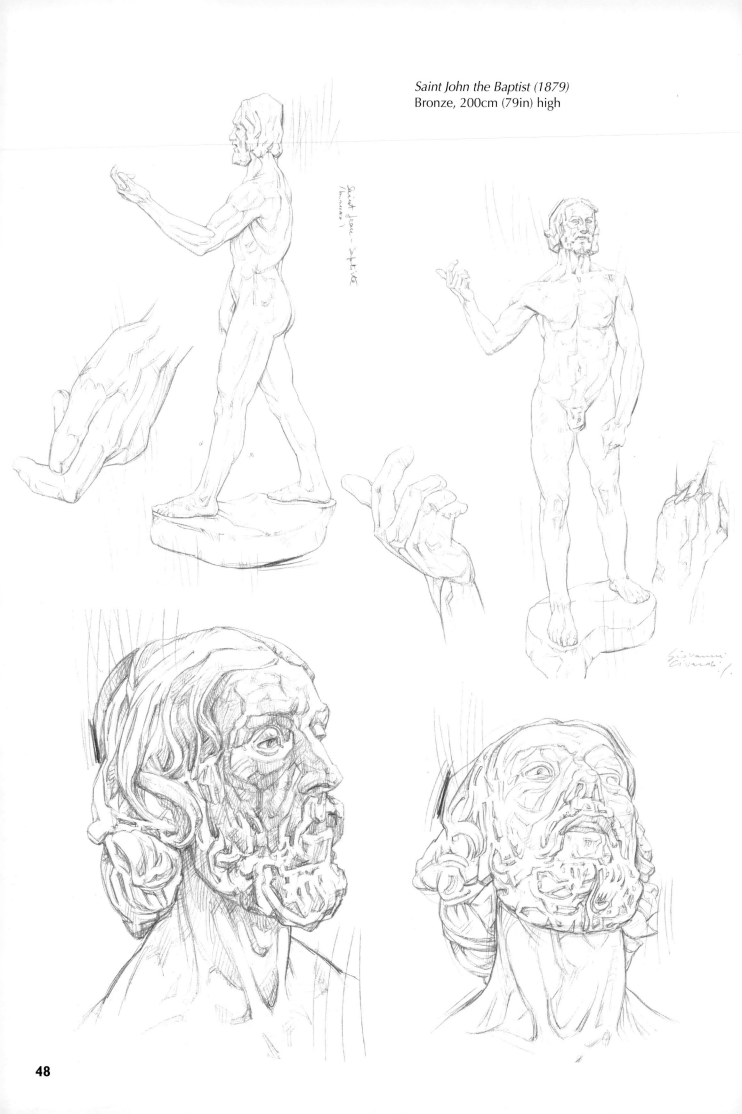

Saint John the Baptist (1879)
Bronze, 200cm (79in) high

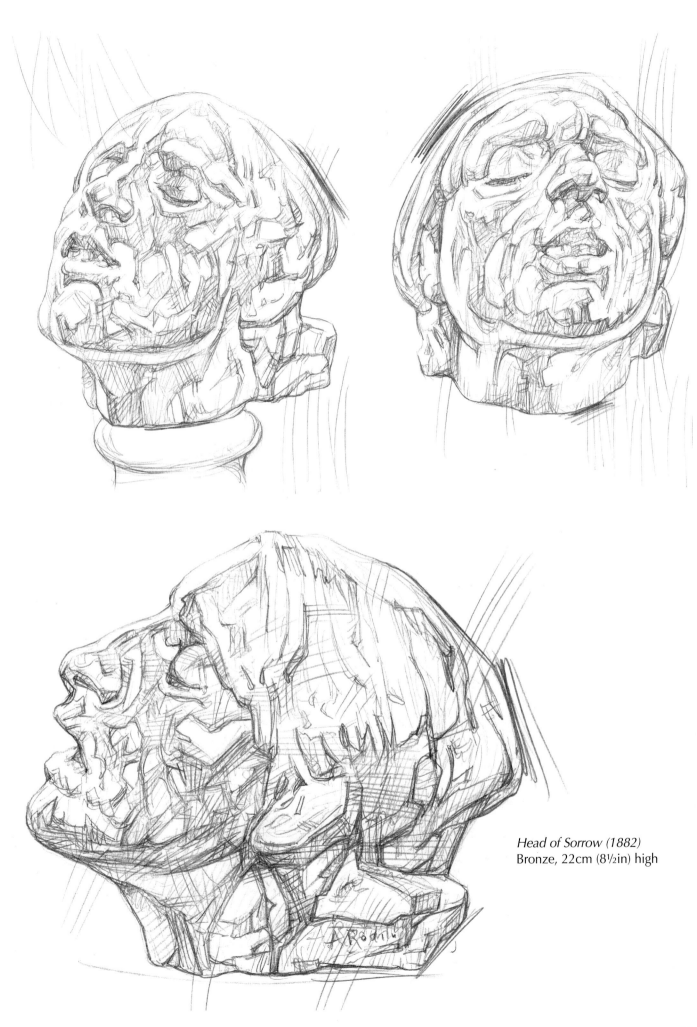

Head of Sorrow (1882)
Bronze, 22cm (8½in) high

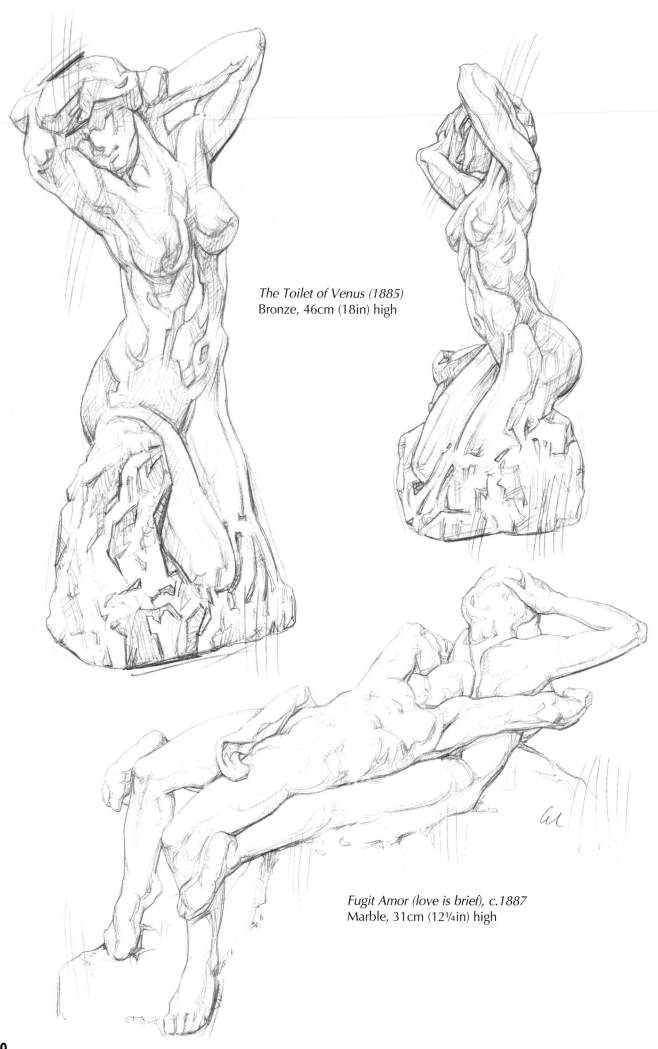

The Toilet of Venus (1885)
Bronze, 46cm (18in) high

Fugit Amor (love is brief), c.1887
Marble, 31cm (12¼in) high

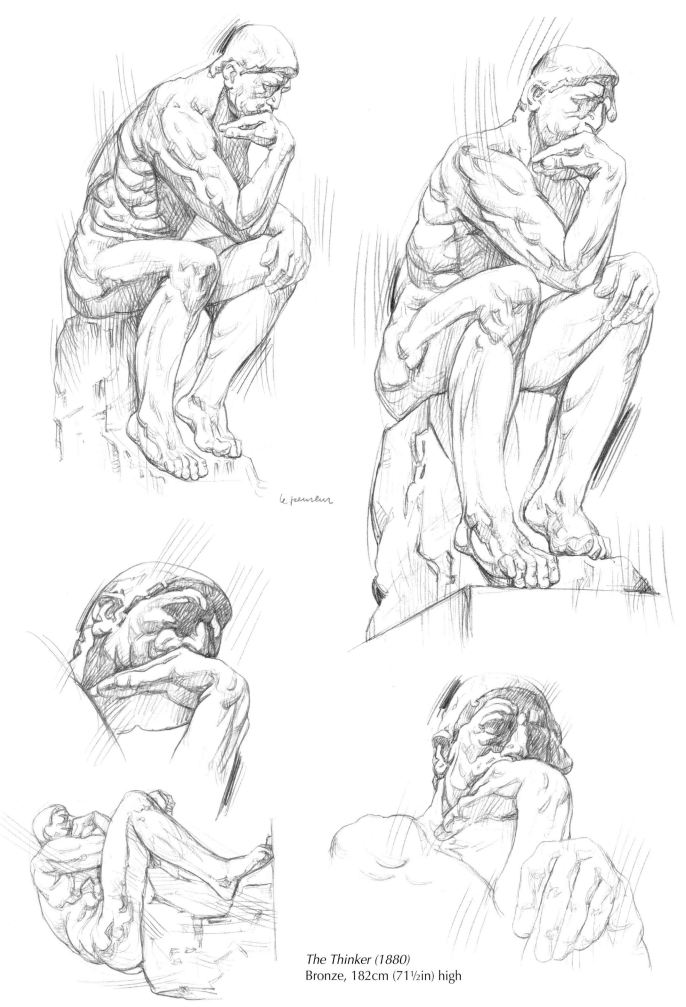

The Thinker (1880)
Bronze, 182cm (71½in) high

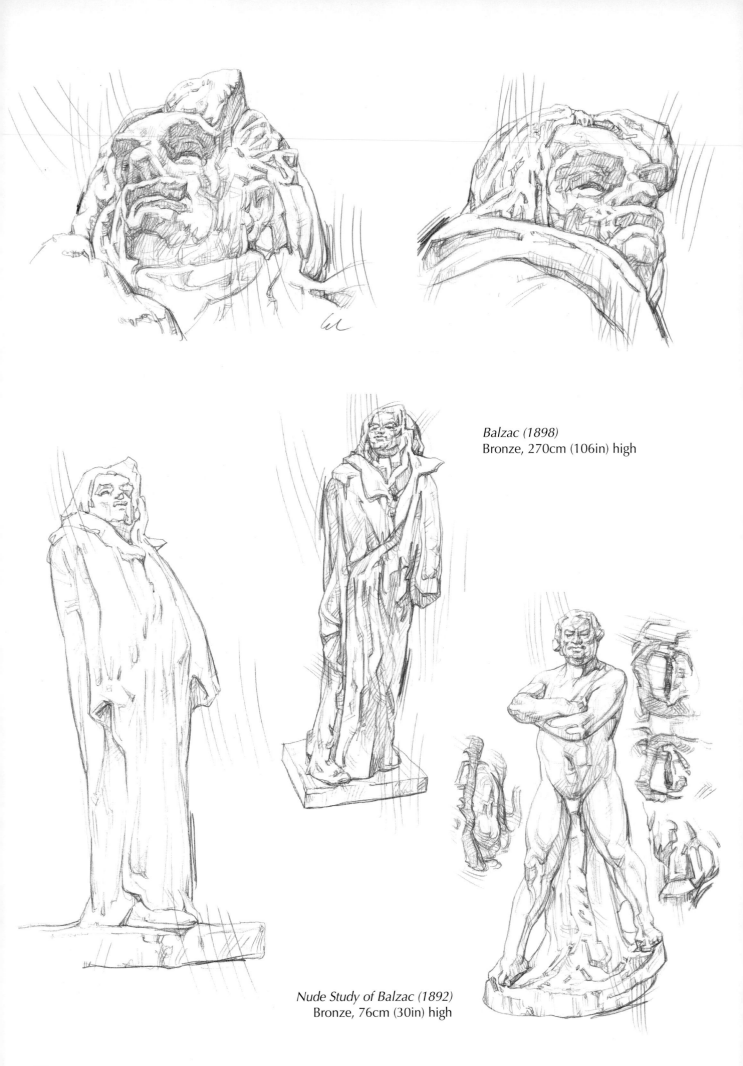

Balzac (1898)
Bronze, 270cm (106in) high

Nude Study of Balzac (1892)
Bronze, 76cm (30in) high

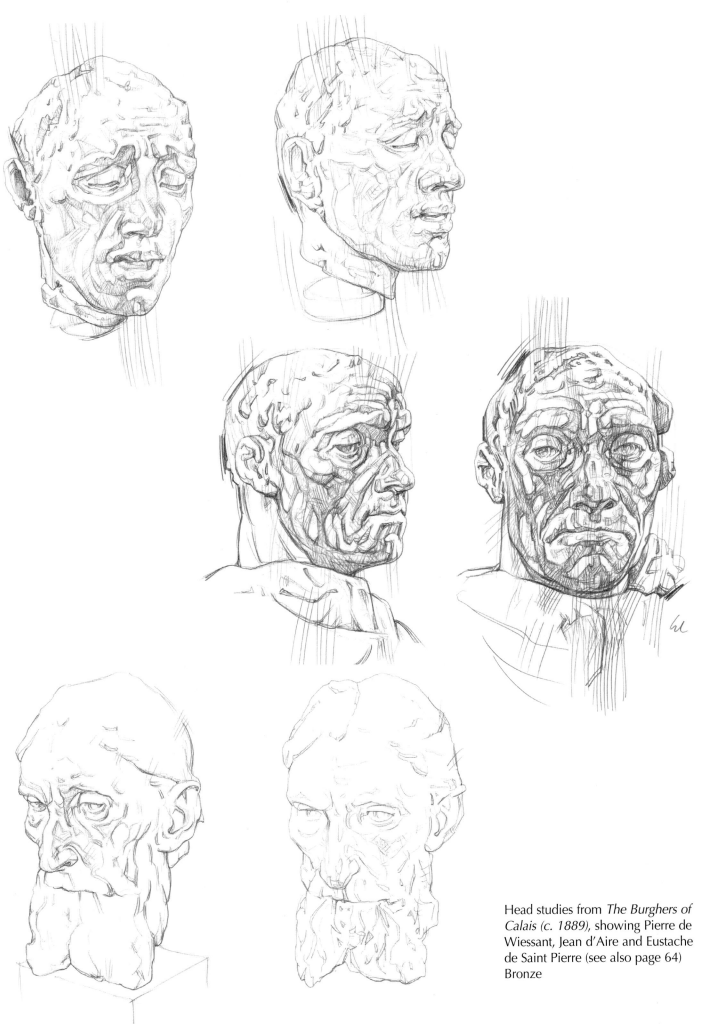

Head studies from *The Burghers of Calais (c. 1889)*, showing Pierre de Wiessant, Jean d'Aire and Eustache de Saint Pierre (see also page 64) Bronze

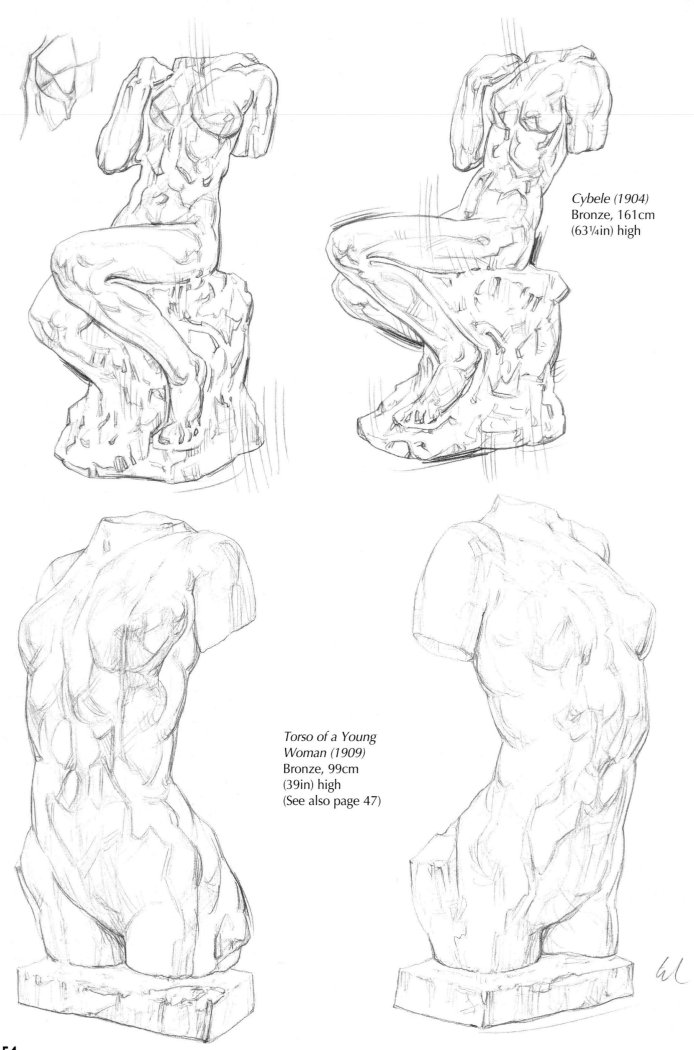

Cybele (1904)
Bronze, 161cm
(63¼in) high

*Torso of a Young
Woman (1909)*
Bronze, 99cm
(39in) high
(See also page 47)

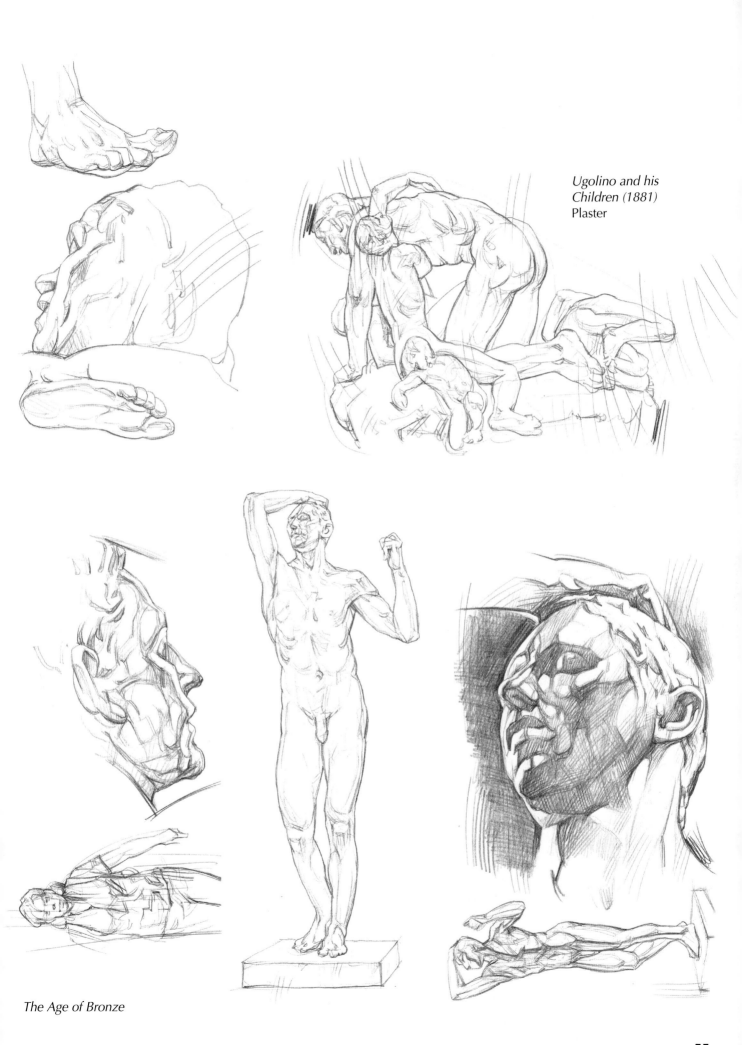

Ugolino and his
Children (1881)
Plaster

The Age of Bronze

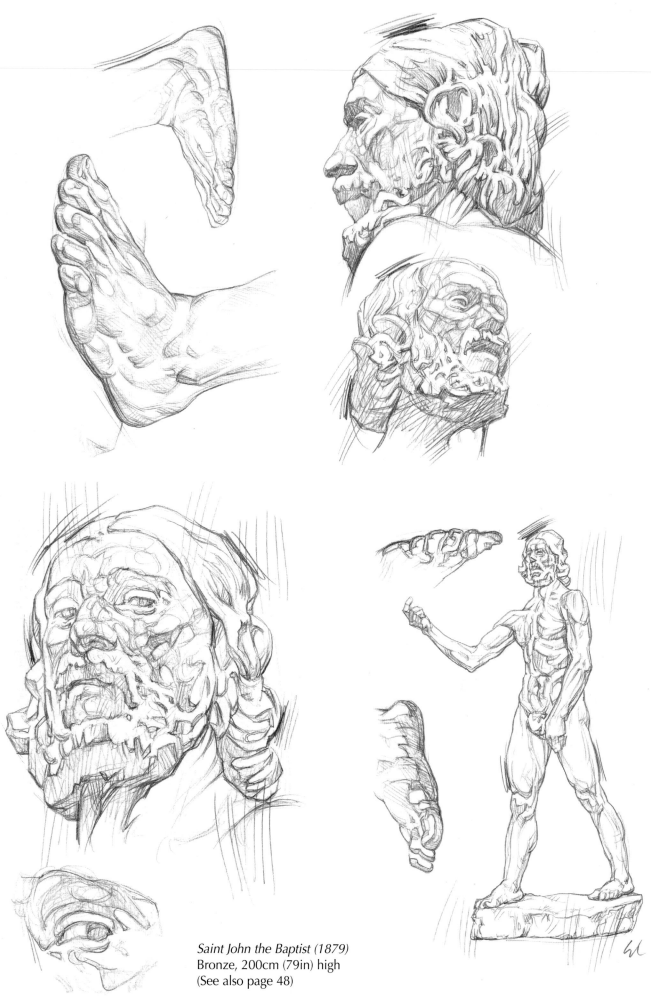

Saint John the Baptist (1879)
Bronze, 200cm (79in) high
(See also page 48)

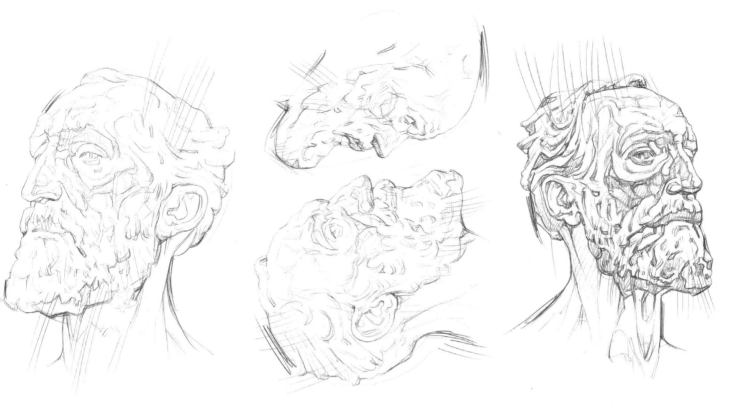

Portrait of Jules Dalou (1883)
Bronze, 57cm (22½in) high

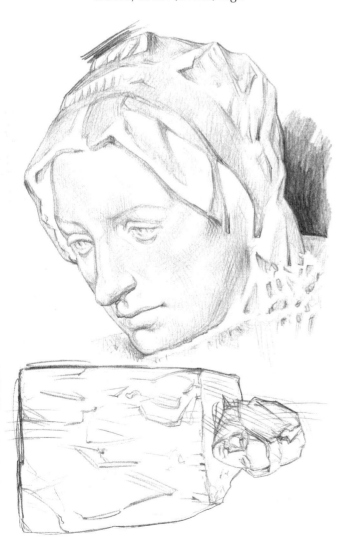

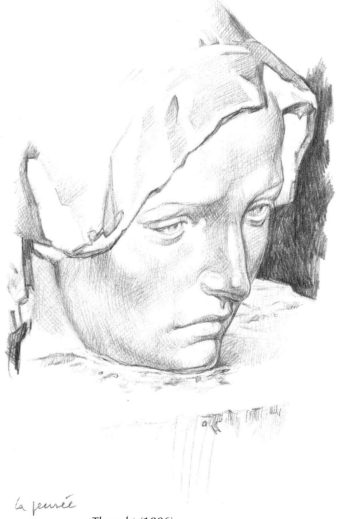

La pensée

Thought (1886)
Marble, 74cm (29in) high

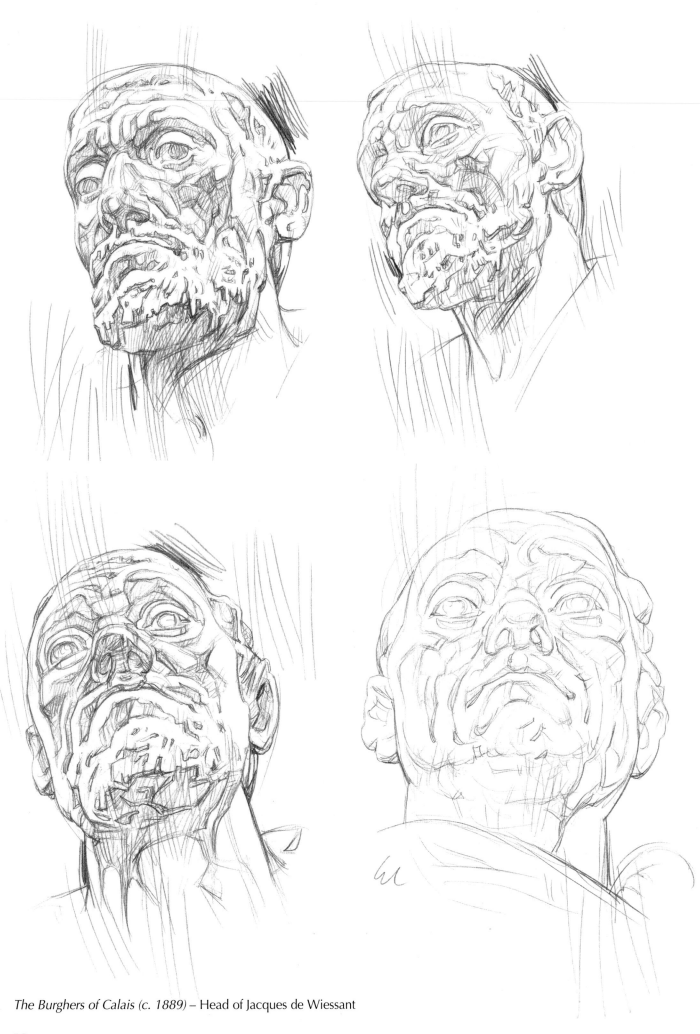

The Burghers of Calais (c. 1889) – Head of Jacques de Wiessant

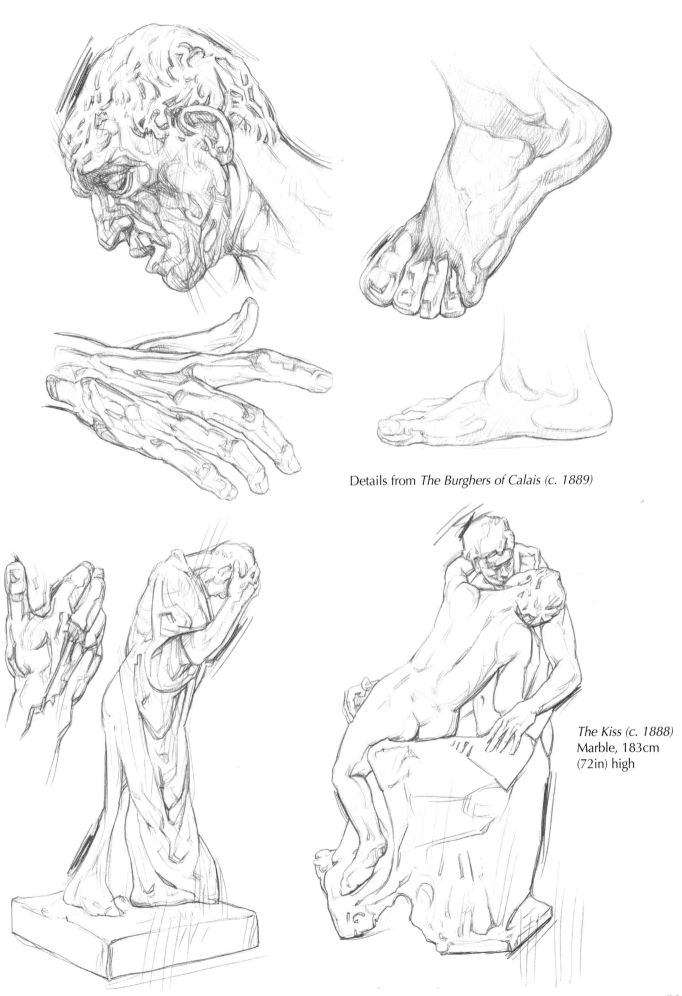

Details from *The Burghers of Calais (c. 1889)*

The Kiss (c. 1888)
Marble, 183cm
(72in) high

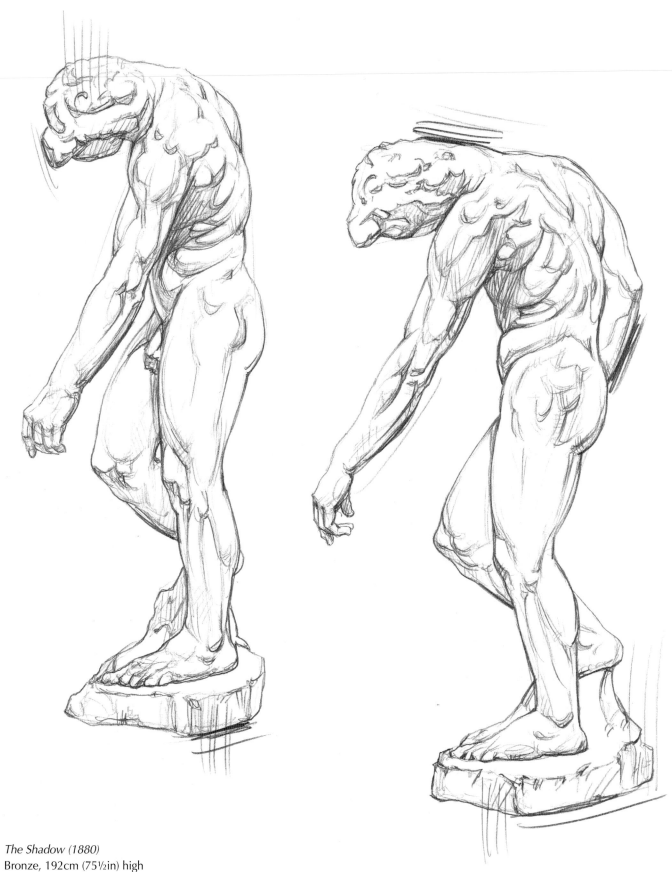

The Shadow (1880)
Bronze, 192cm (75½in) high

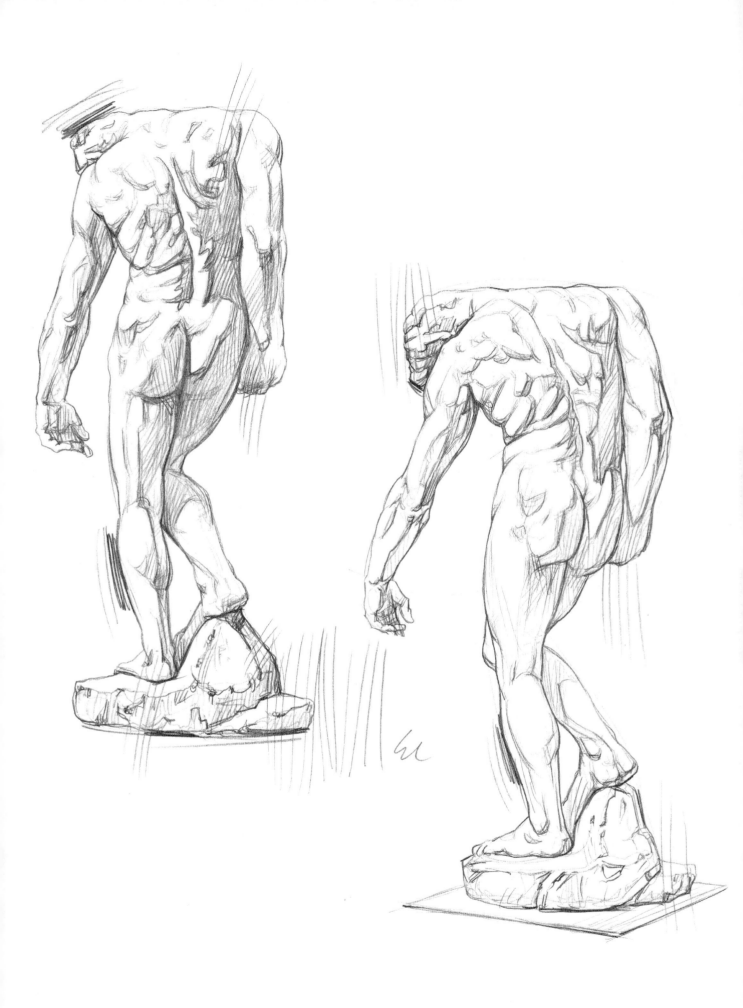

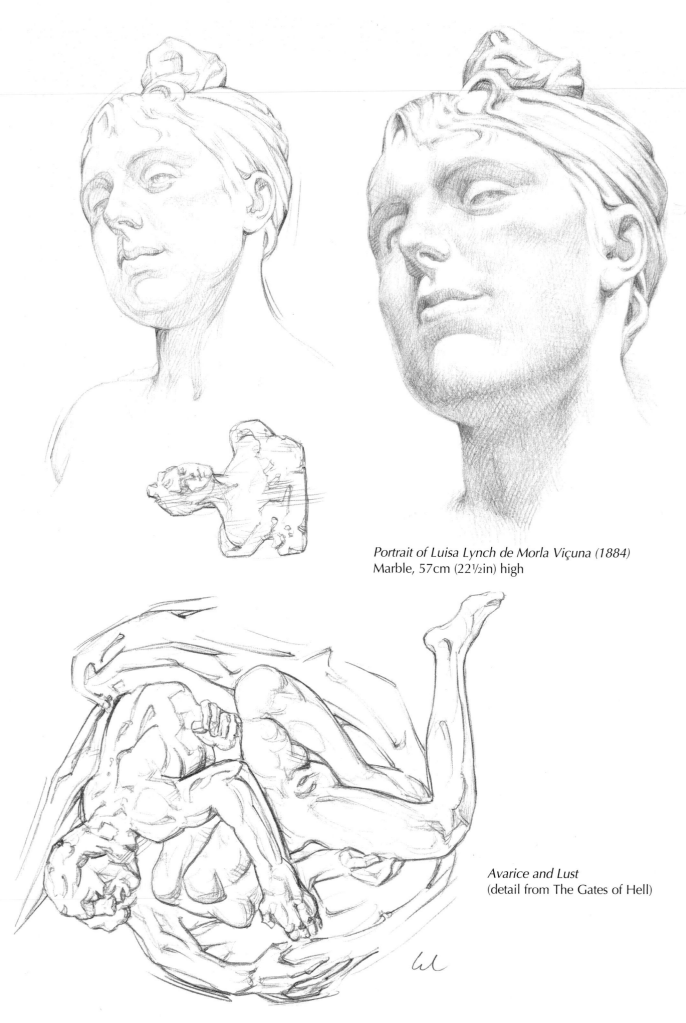

Portrait of Luisa Lynch de Morla Viçuna (1884)
Marble, 57cm (22½in) high

Avarice and Lust
(detail from The Gates of Hell)

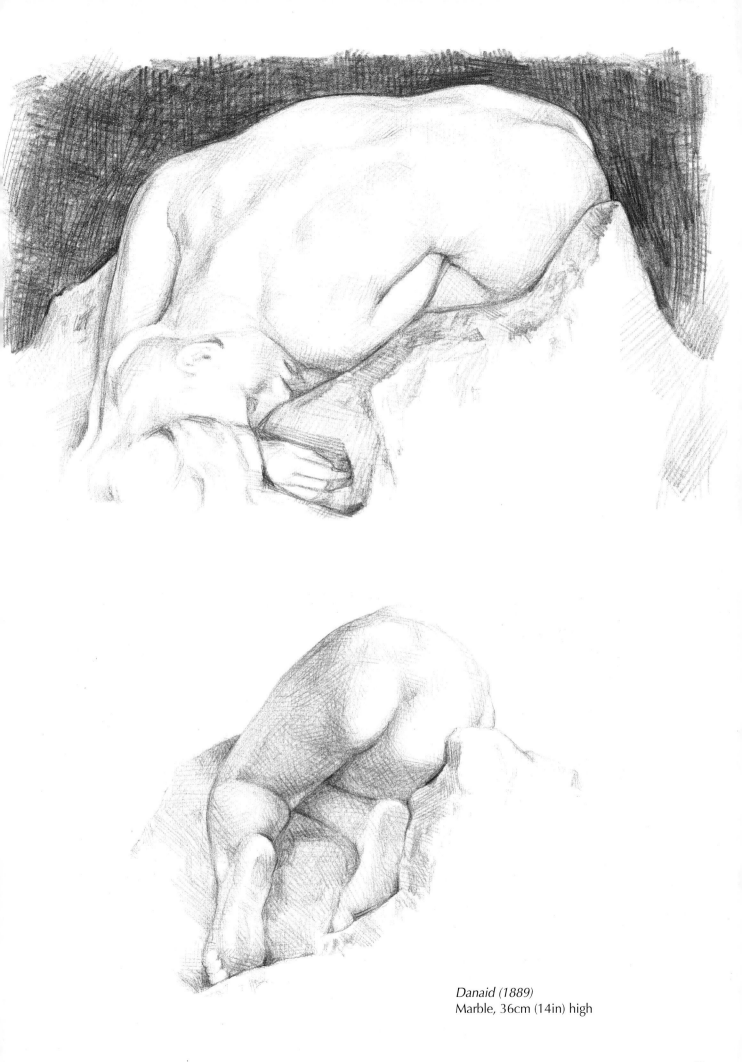

Danaid (1889)
Marble, 36cm (14in) high

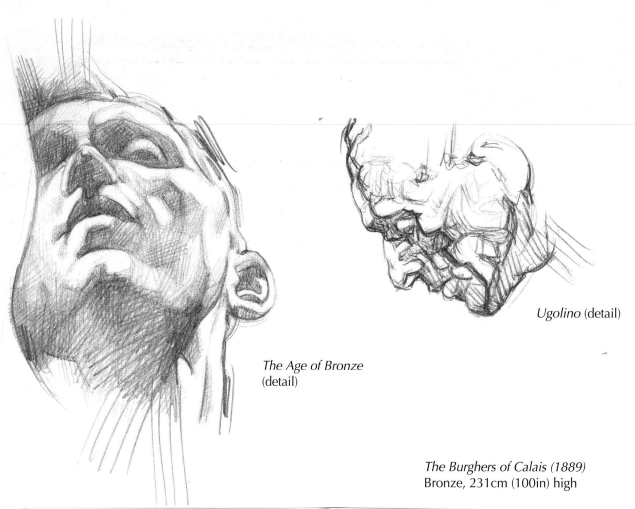

Ugolino (detail)

The Age of Bronze
(detail)

The Burghers of Calais (1889)
Bronze, 231cm (100in) high

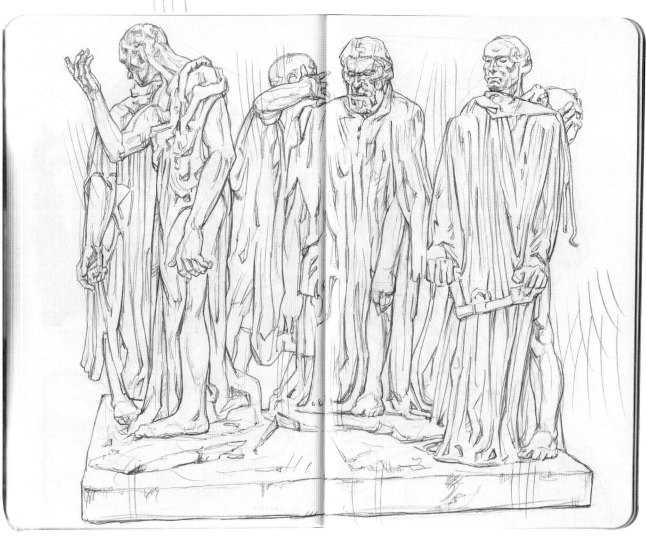